THE BEST OF EAST AFRICAN
WILDLIFE

INTRODUCTION

East Africa is a land of contrasts. Its habitats include the ice- and snow-covered Kilimanjaro (Africa's highest mountain), montane forests, tropical rainforests, semi-desert and savannah, mangrove forests, and palm-fringed coast. This variety of habitats and the diverse animals that live here make this the premier wildlife viewing region in Africa. In areas such as the Masai Mara, Ngorongoro and the Serengeti it is not unusual to see the Big Five – black rhino, buffalo, elephant, leopard and lion – on a drive before breakfast. Over 1 400 different birds have been recorded in East Africa and more are added to the list each year.

In the northeast of Kenya are the arid lands of Samburu, Buffalo Springs and Shaba national reserves, where a visitor can see wildlife found nowhere else, such as the endangered Grevy's zebra, Beisa oryx and reticulated giraffe (a subspecies of giraffe). This area is also the home to gerenuk, the long-necked antelope (the name means 'giraffe-necked' in Somali) and some special birds such as the Vulturine Guineafowl, Somali Bee-eater and the stunning Golden-breasted Starling. To the east is Meru National Park, which, after suffering years of neglect and poaching, is being revitalized, and is once again a great place to visit.

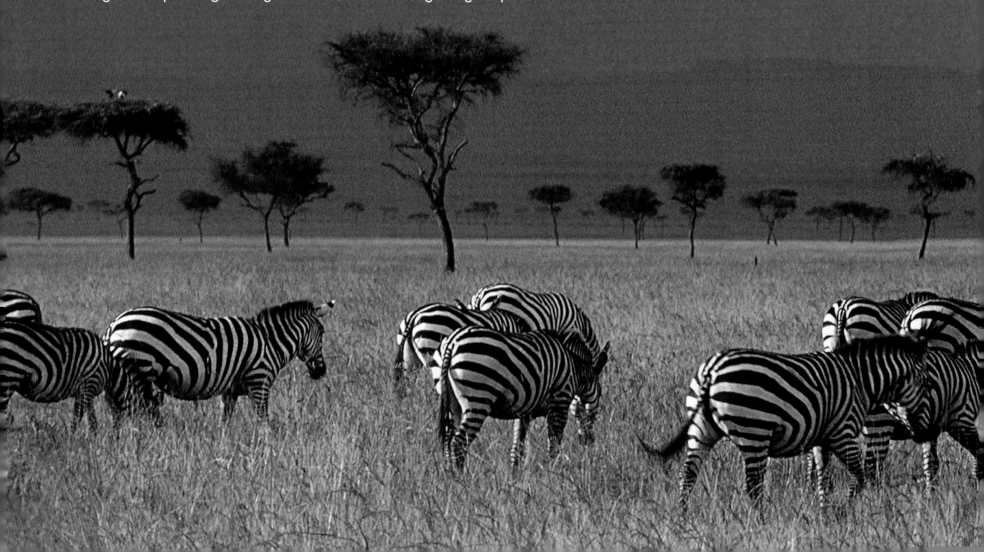

In the southeast are Tsavo East and Tsavo West national parks, famous for their 'red' elephants. Tsavo's earth is red, and this colours the elephants when they wallow in water holes and dust bathe. In Tsavo West it is possible to view and photograph hippo in the crystal clear water of Mzima Springs from the comfort of an observation tank sunk into the riverbank. One of Africa's rarest antelope, the hirola, is also found in Tsavo East.

In the southwest of Kenya is the famous Masai Mara National Reserve, well known for its abundance of wildlife, particularly its cats, and where, between July and September, the famous wildebeest migration takes place. South of Nairobi, adjacent to the Tanzanian border, is Amboseli National Park, renowned for its views of snow-capped Kilimanjaro. It forms a magnificent backdrop to the wildlife at its base and a photograph of one of Amboseli's large-tusked male elephants with Kilimanjaro as a backdrop is a must for all wildlife photographers.

Roughly bisecting Kenya is the Great Rift Valley, which continues down into Tanzania. The valley encloses a string of lakes, mostly alkaline, whose shores are frequently lined pink with flamingos. The best known of these lakes, Lake Nakuru, is at times home to more than a million Lesser Flamingos. Nakuru is also the best location to see and photograph black and white rhino. The elusive leopard may also be spotted lying along the branch of a yellow-barked acacia tree.

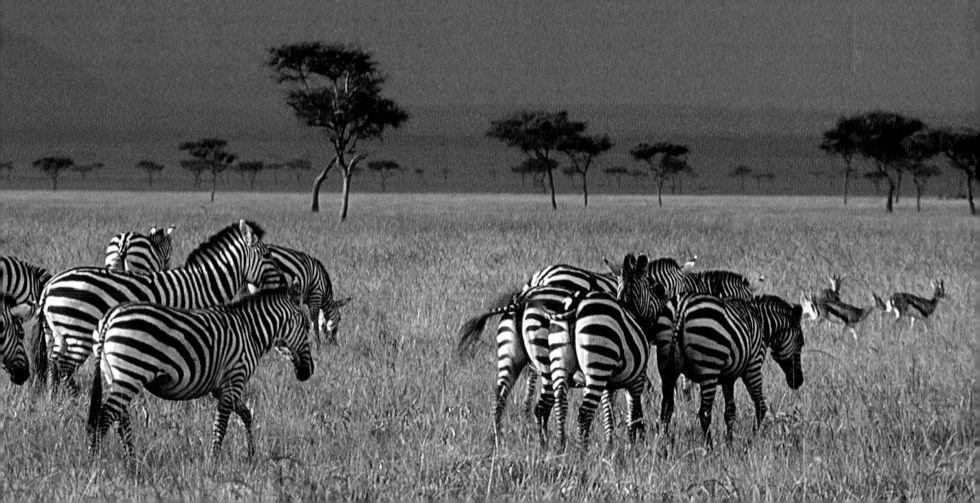

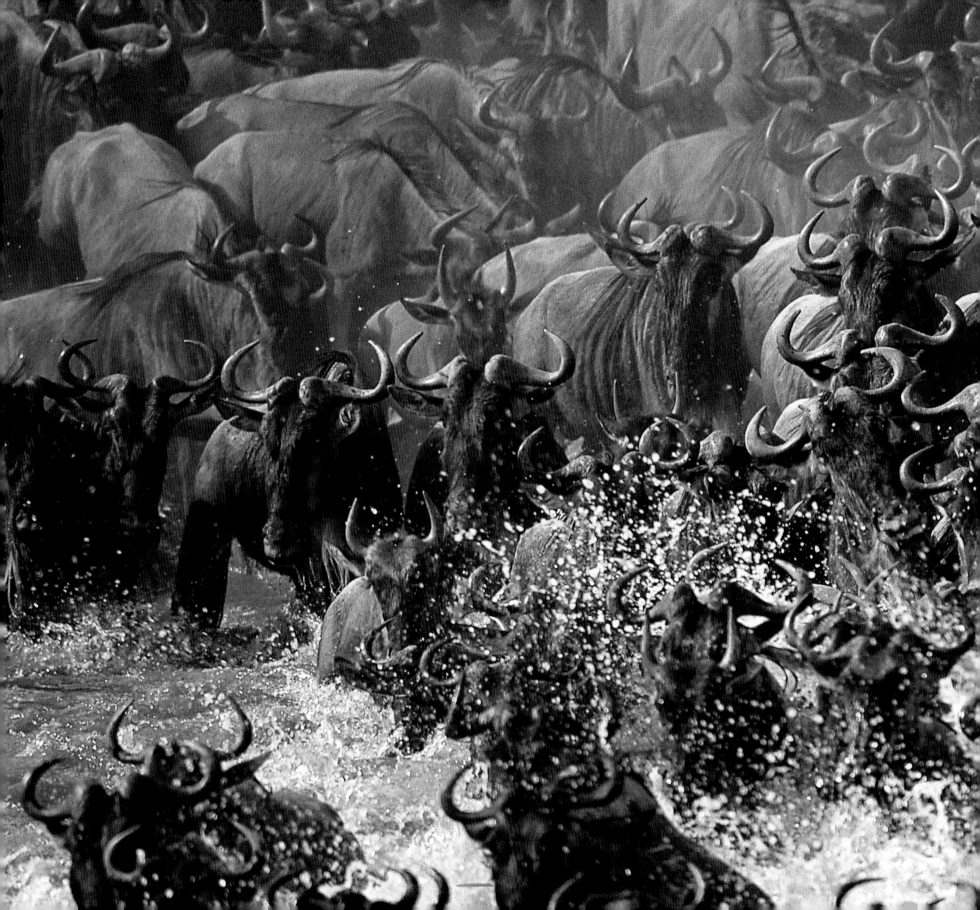

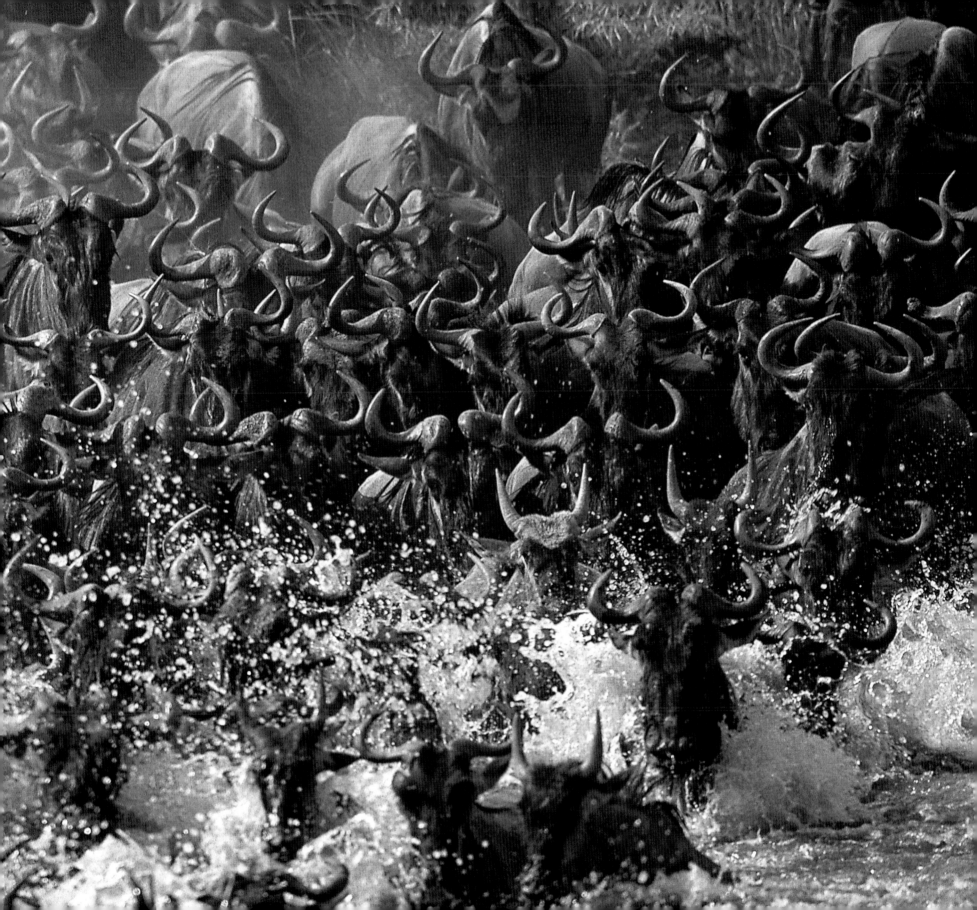

This photograph of a black rhinoceros with her calf was taken at Lewa Downs Conservatory in Northern Kenya in March 2006. Red-billed Oxpeckers 'adorn' the mother's back.

Private wildlife conservancies in Kenya have had great success in protecting the black rhino and helping to increase their numbers. These conservancies are surrounded by electric fences and patrolled by armed rangers. The Lewa Wildlife Conservancy has been particularly successful with both black and white rhinos and has moved some to other areas such as Meru National Park. There are now over 50 black rhinos at Lewa.

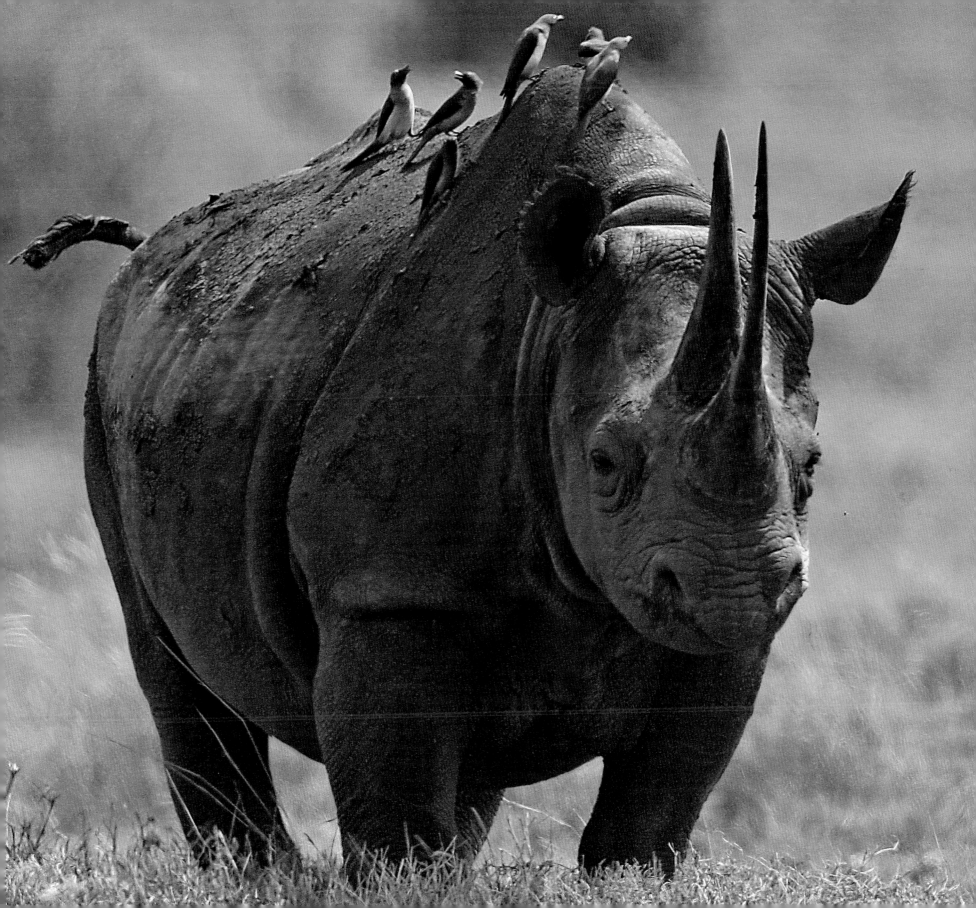

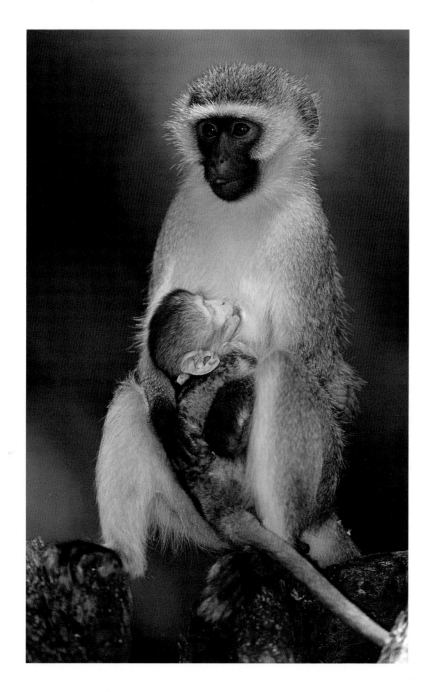
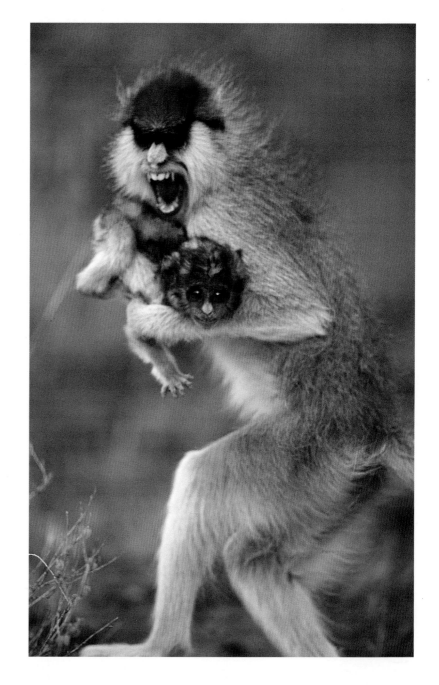

ABOVE LEFT A black-faced vervet mother suckles her young infant in Samburu Game Reserve in Northern Kenya.

ABOVE RIGHT A female patas monkey in Laikipia Plateau, Central Kenya, has stolen the baby of a distracted mother and carries it a little distance before releasing it unharmed.

OPPOSITE Two young mountain gorillas tussle while at play in the rain forests of the Bwindi Impenetrable Forest National Park in Uganda.

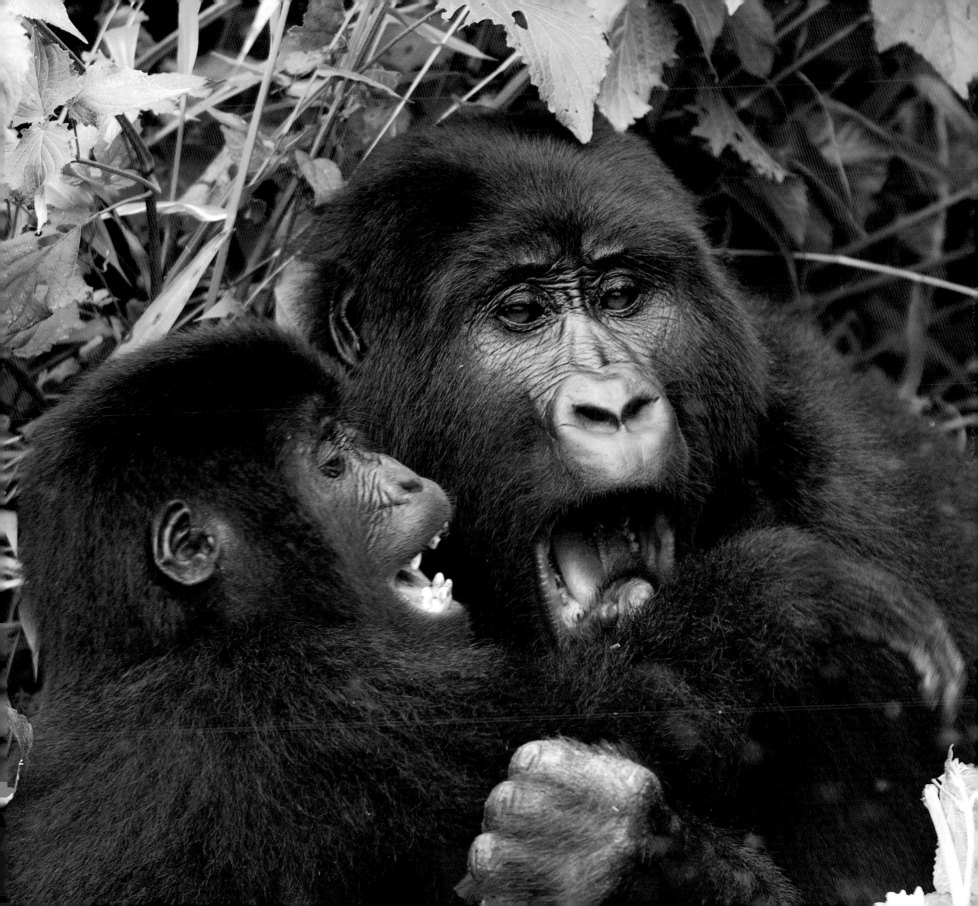

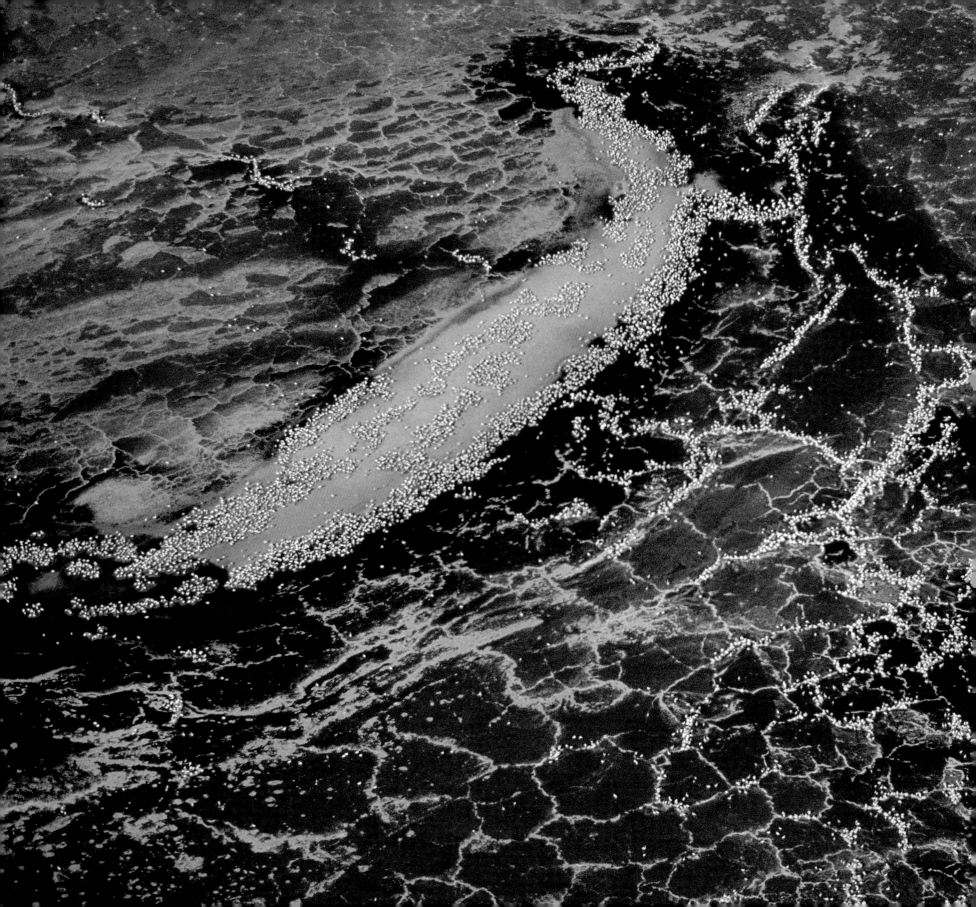

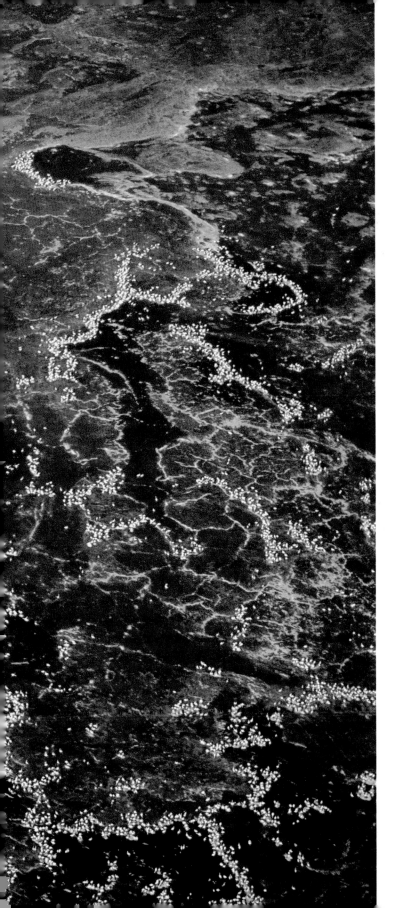

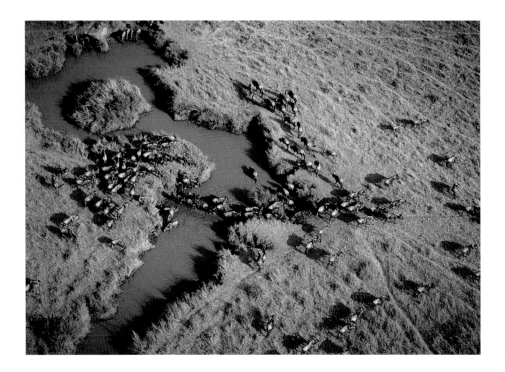

LEFT Aerial view of a Lesser Flamingo nesting colony situated on the mudflats in the centre of the soda-encrusted Lake Natron, Tanzania.

ABOVE From the air the wildebeest look like slow-moving ants as they spread out to feed on the short grass plains of Serengeti National Park, Tanzania.

NEXT SPREAD Each year when the rains fill the lakes and pans of Amboseli National Park, waders and waterbirds flock to their shores. Here, Great White Pelicans take a breather from feeding to preen their glossy plumage.

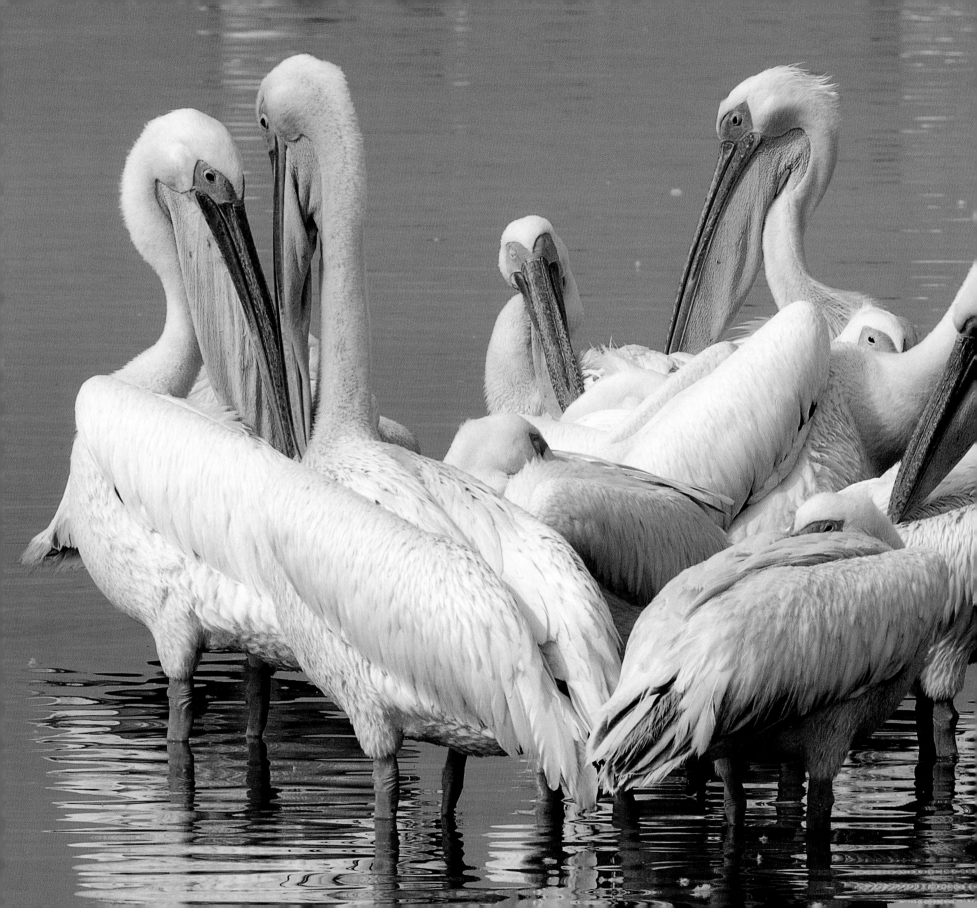

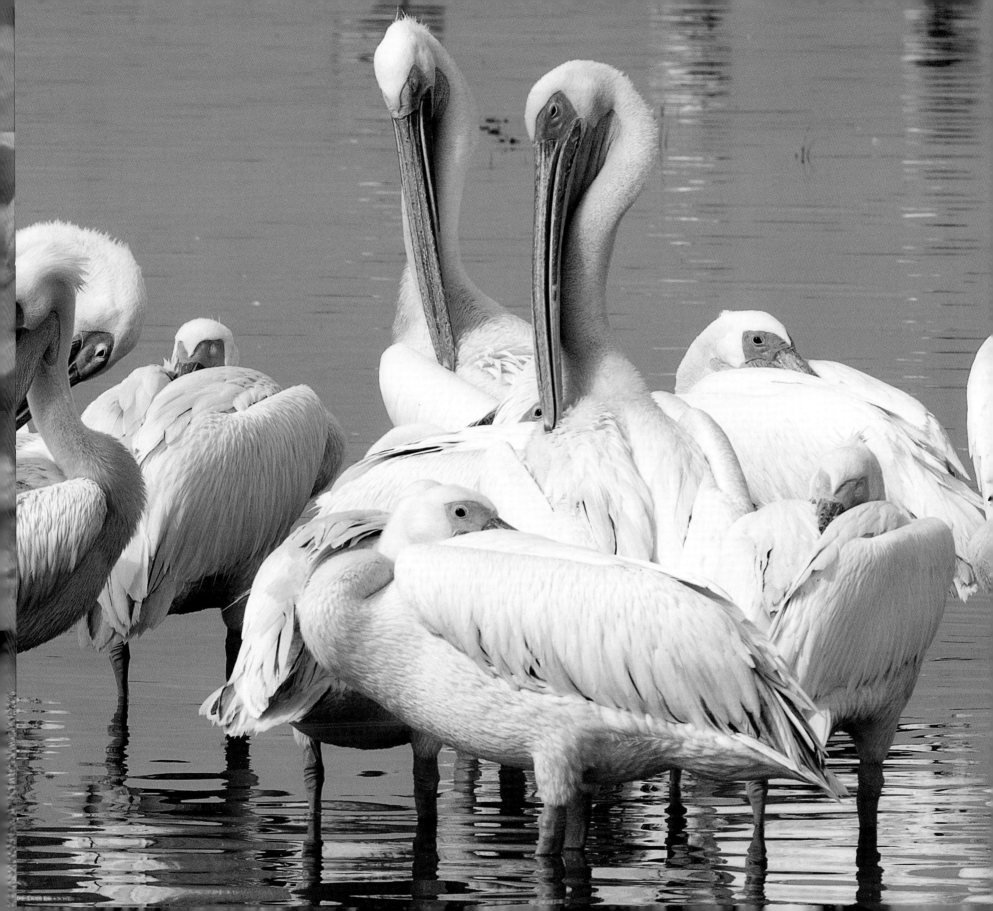

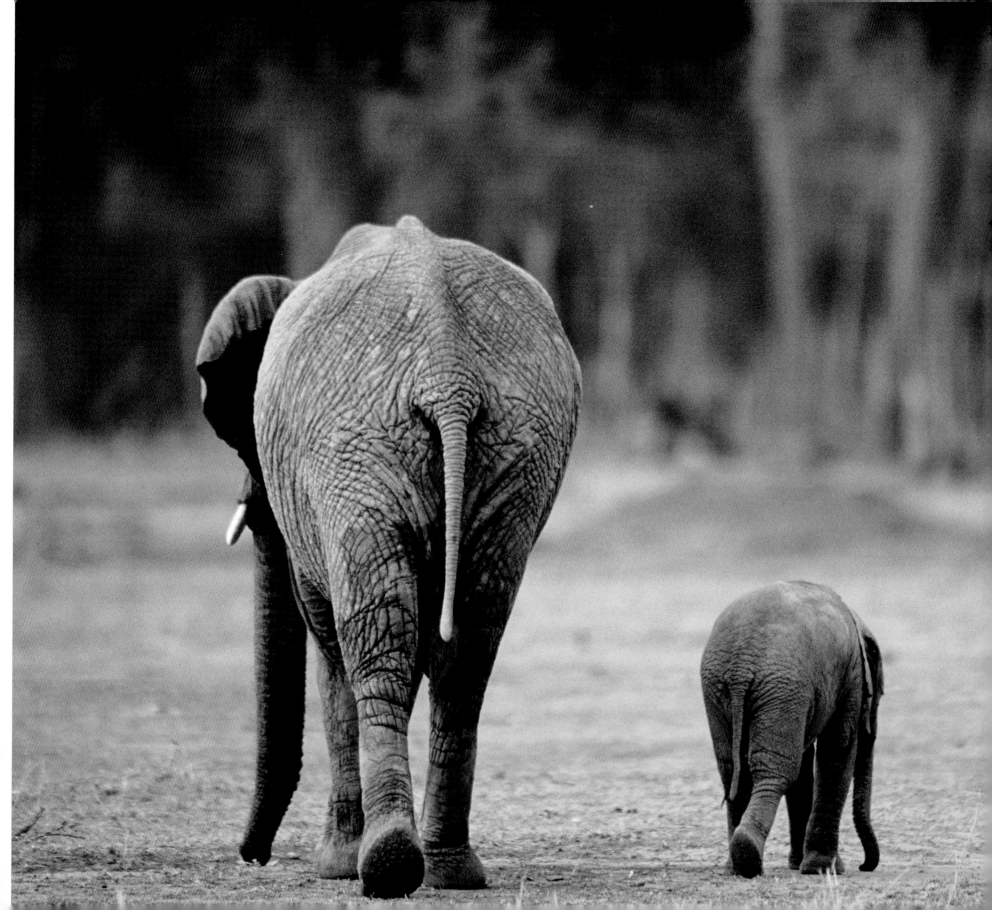

LEFT A mother African elephant, her calf constantly at her side, moves towards the riverine forest of the Mara River, Masai Mara National Reserve, grazing as she makes her way across the plains.
BELOW A rhino baby follows its grazing mother in Lake Nakuru National Park, Kenya.
NEXT SPREAD Reticulated giraffes browse on the leaves of acacia trees in Samburu National Reserve, in Northern Kenya. They must use their tongues skillfully to avoid sharp thorns.

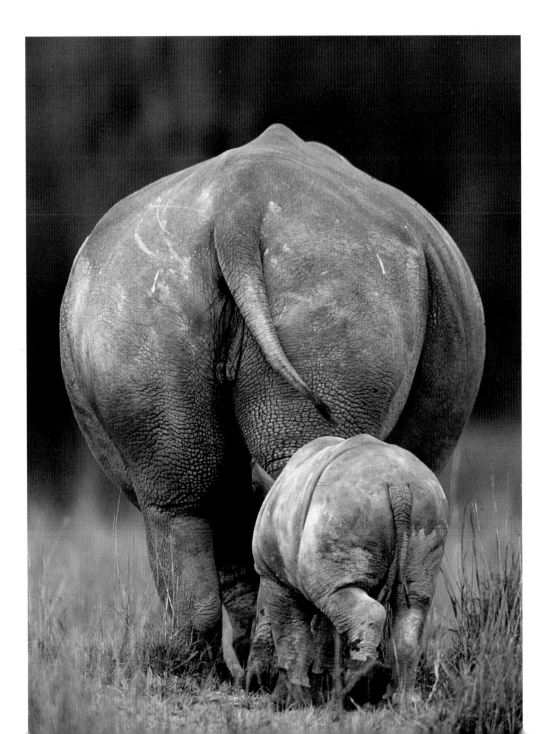

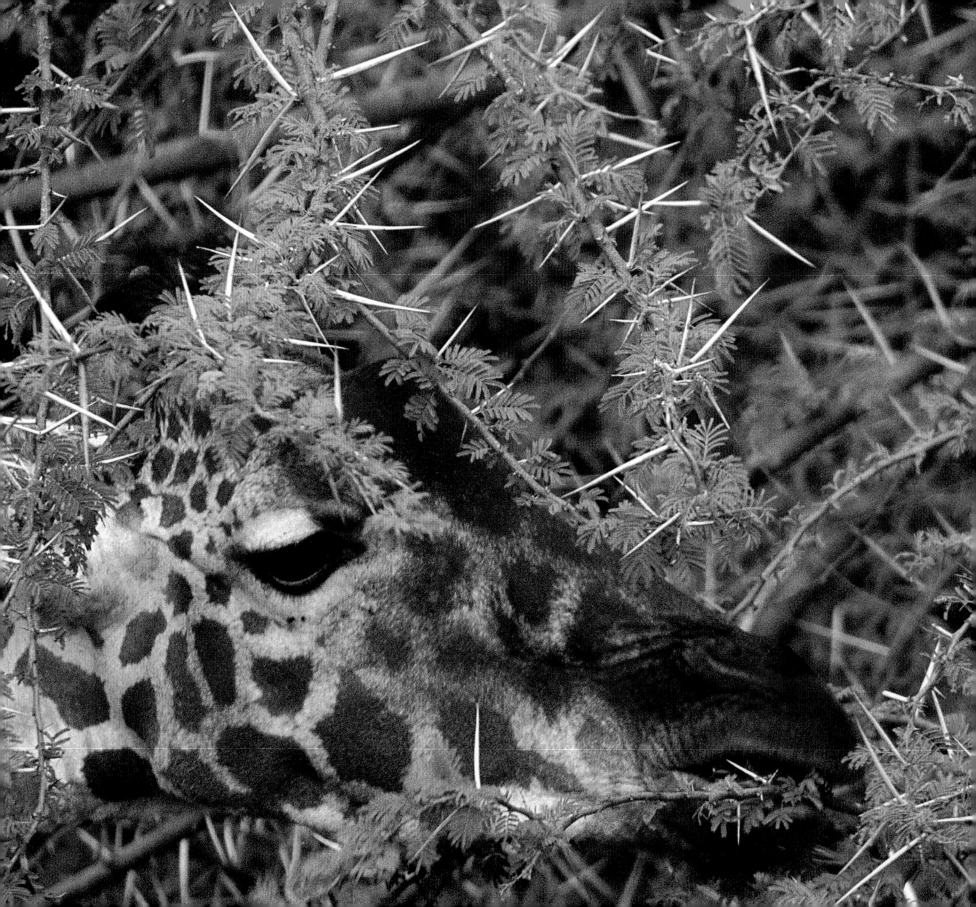

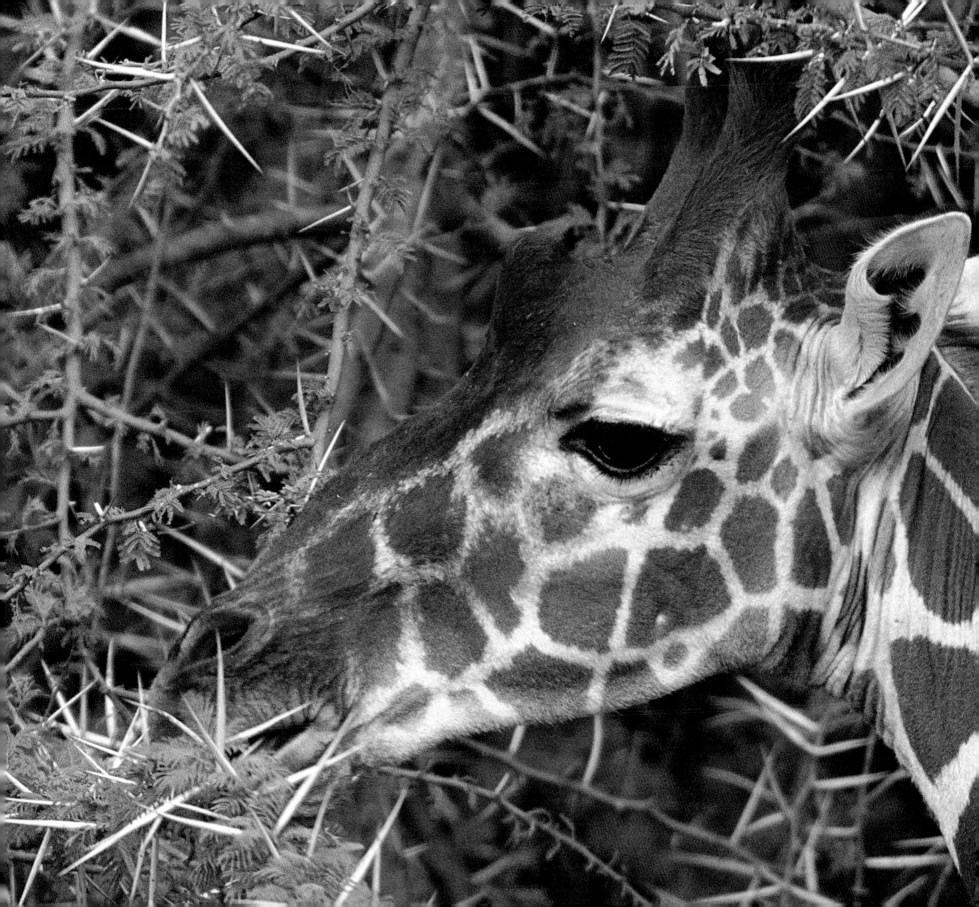

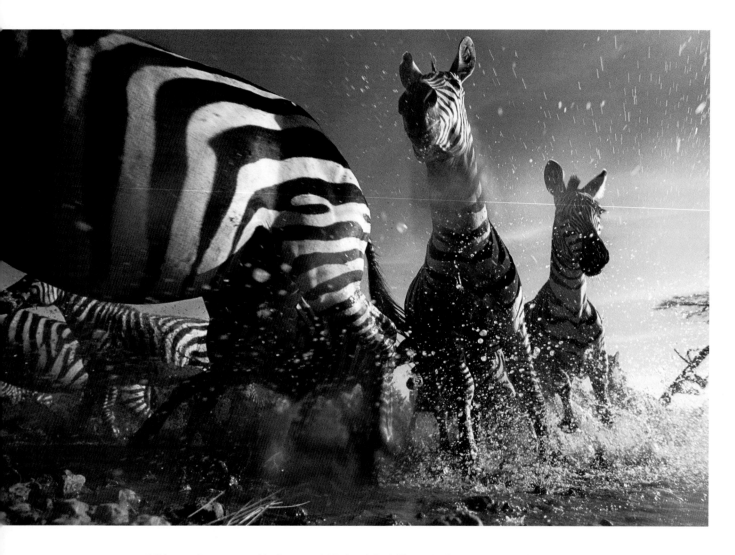

ABOVE Mid-morning at a pool in Serengeti National Park, Tanzania. Drinking zebras flee in panic, suspecting an ambush.

RIGHT Part of the migration between Serengeti National Park in the south and the Masai Mara in the north, wildebeest line up on the banks of the Mara River in search of greener pastures.

NEXT SPREAD Elephants move out of the woodland at the base of Mt Kilimanjaro, where they have spent the night, travelling towards the open grasslands and swamps that make up much of Amboseli National Park. Researchers from the Amboseli Elephant Research Project have studied their particular population for more than 40 years.

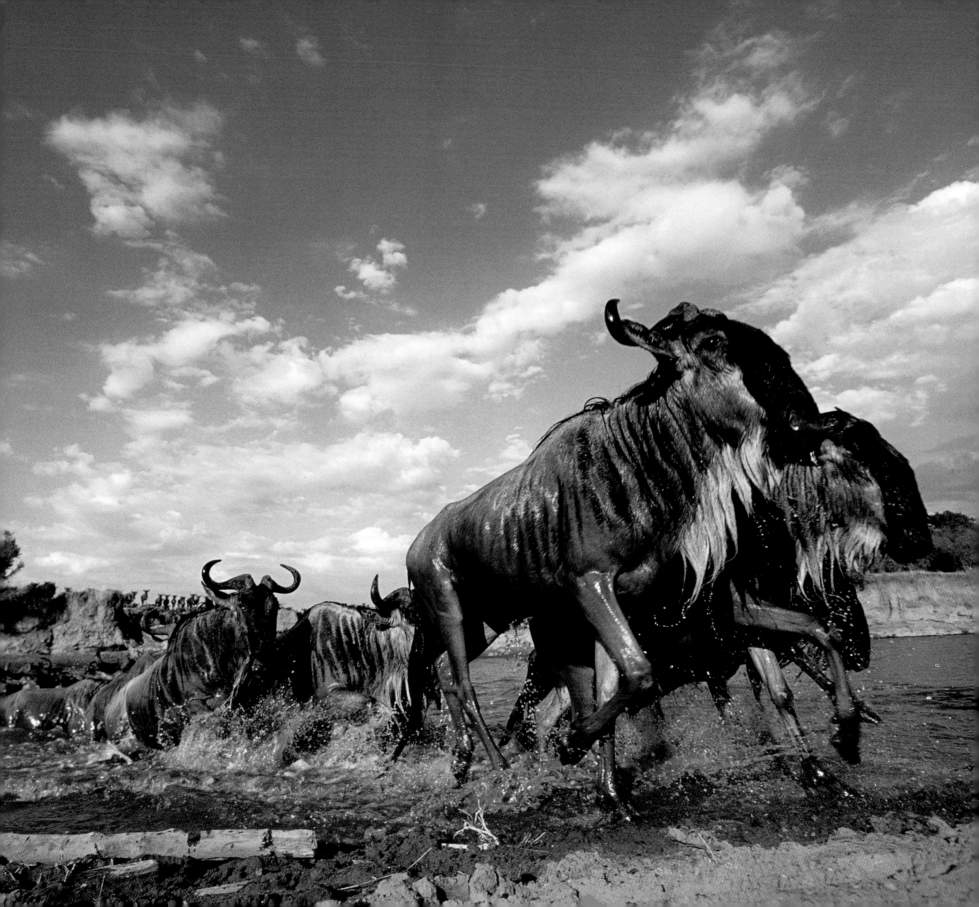

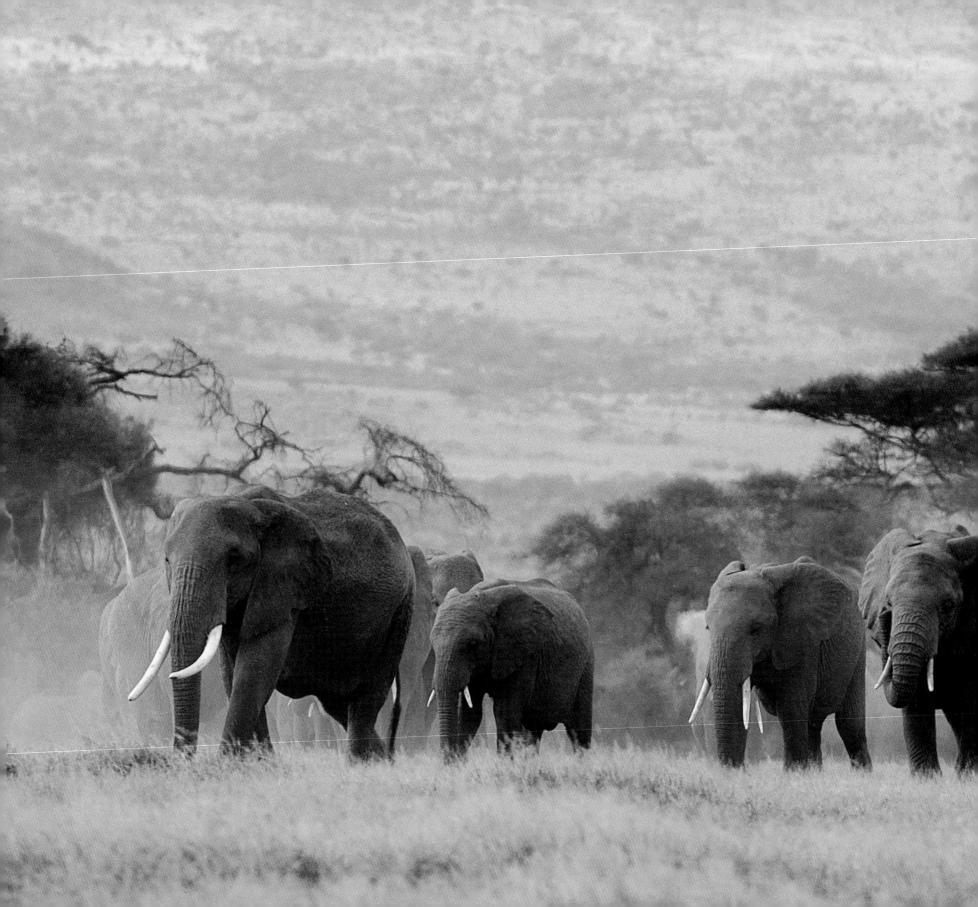

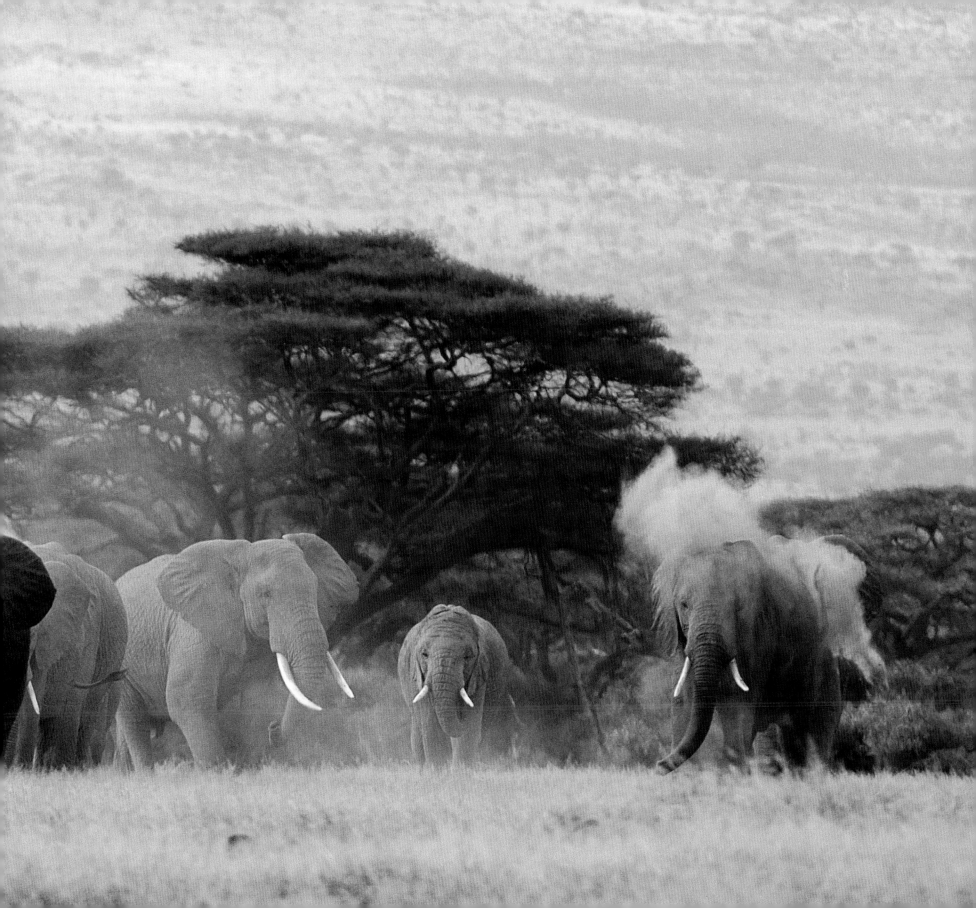

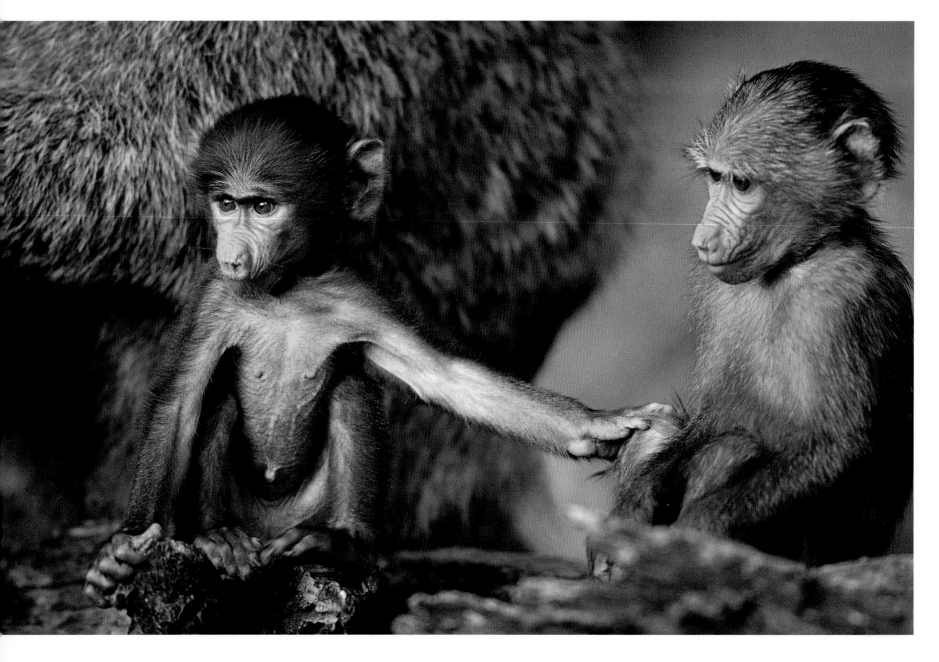

ABOVE Olive baboon babies, part of a group of mothers and their young, enjoy the warmth of the early morning sunlight in Samburu National Reserve in Northern Kenya, before the group commences the day's foraging.

OPPOSITE Three juvenile common chimpanzees huddle together for comfort and companionship at Sweetwaters Sanctuary in Central Kenya.

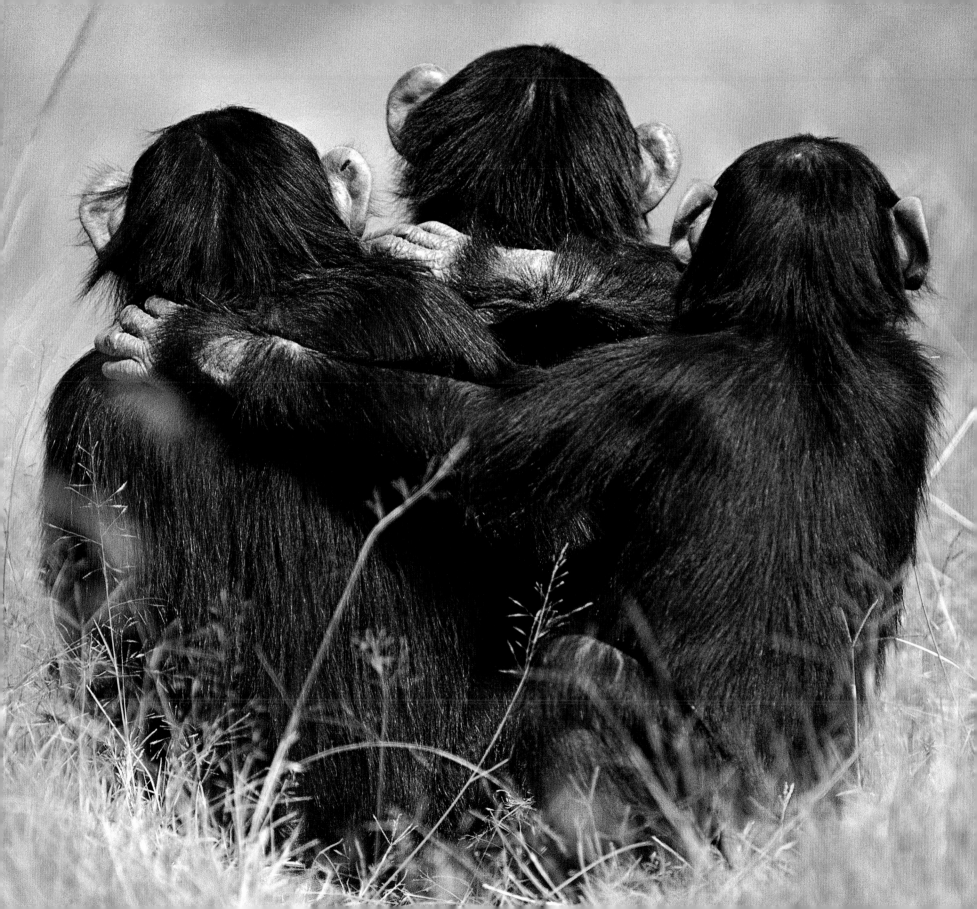

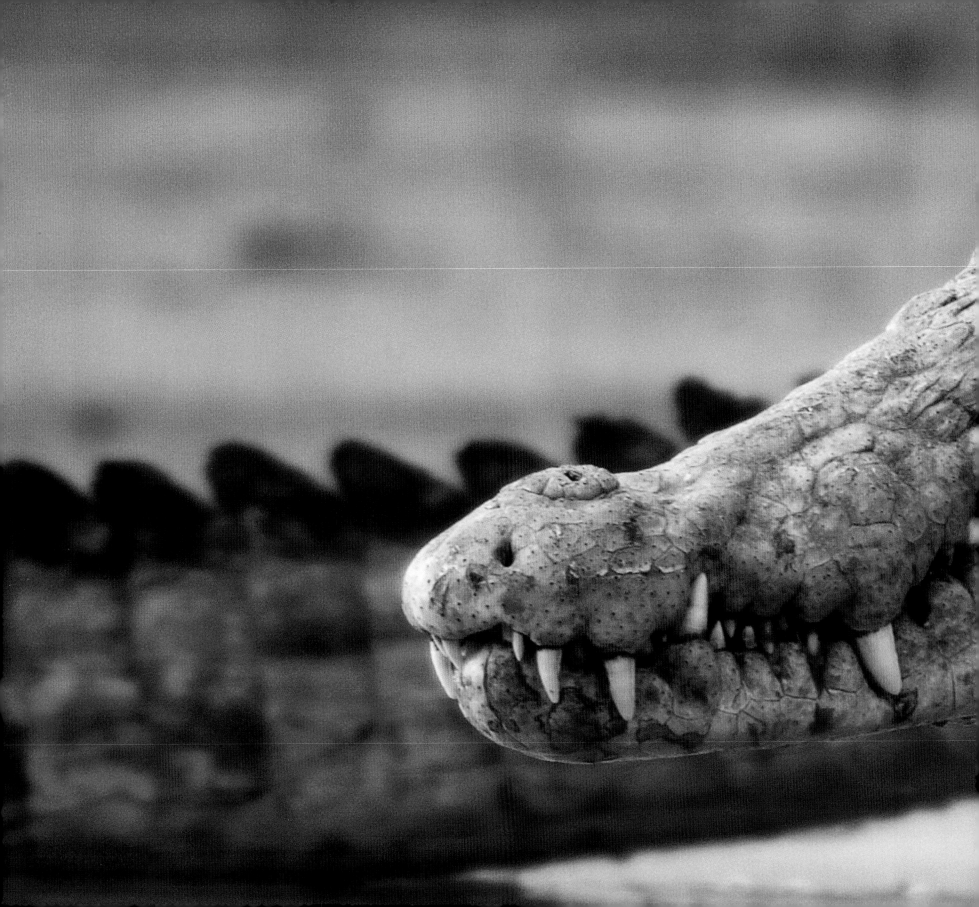

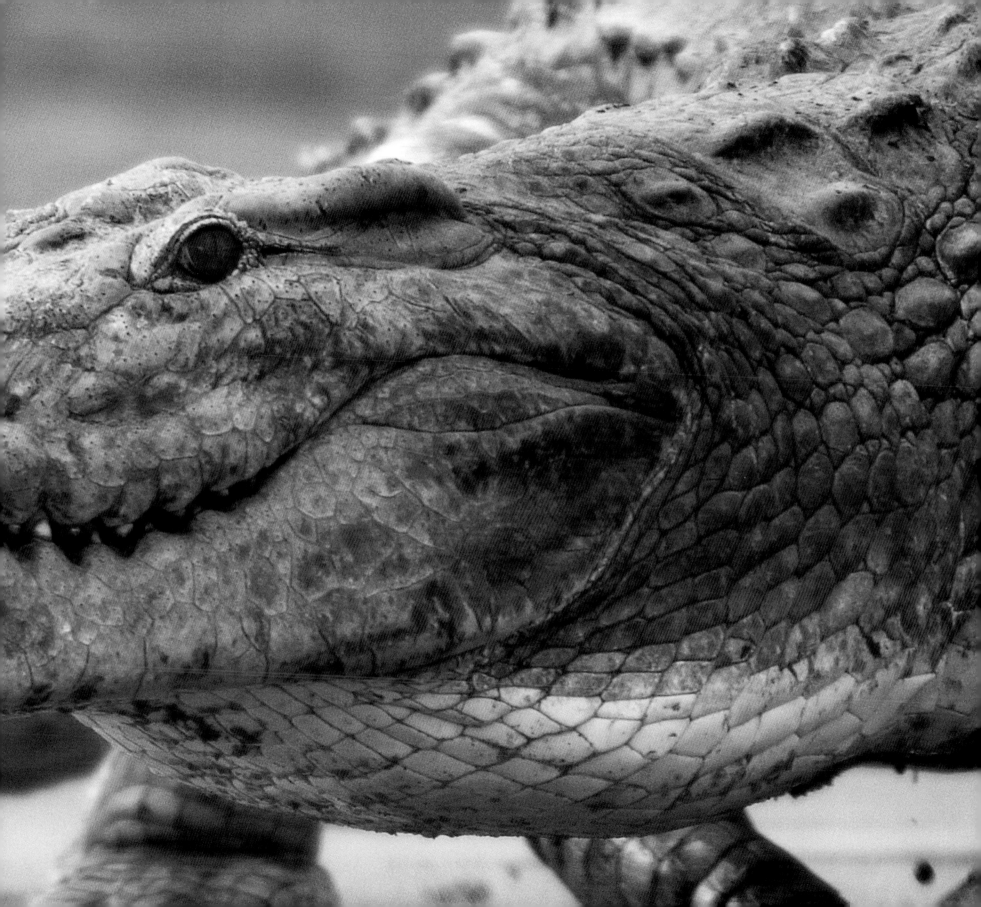

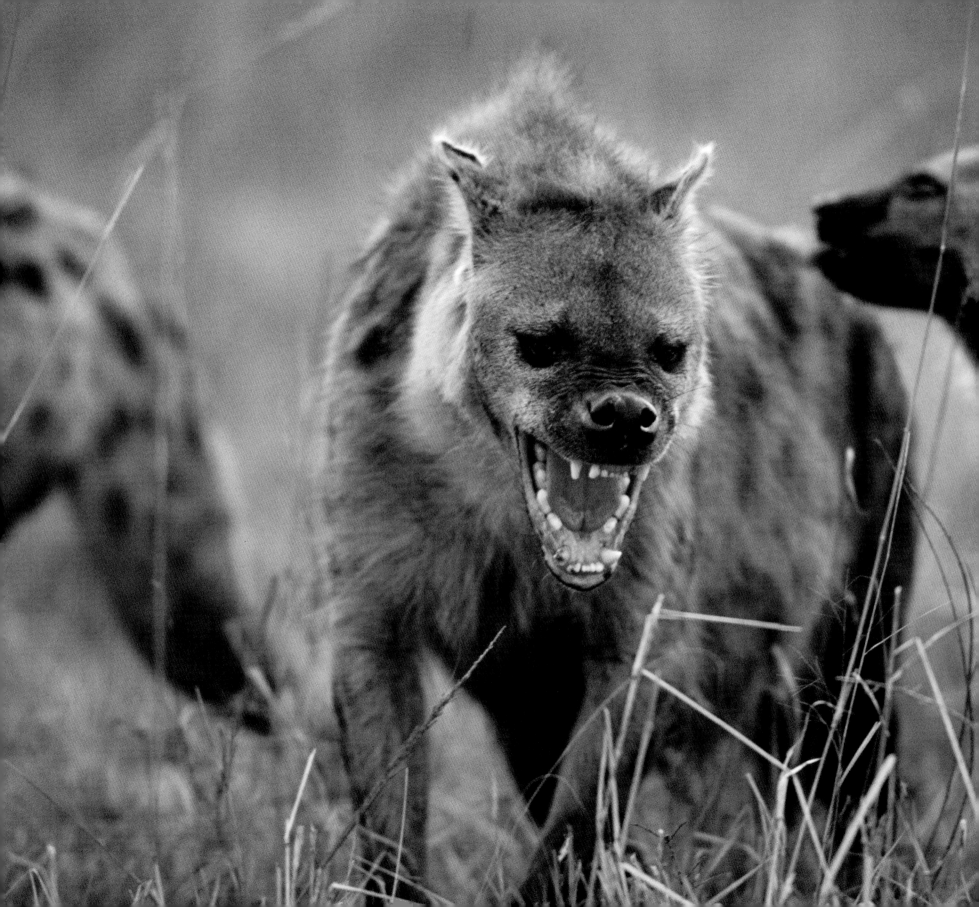

LEFT Upon returning to the den after a night of hunting and scavenging in the Serengeti National Park, Tanzania, a spotted hyaena gestures to youngsters at the den to leave it alone.

BELOW Within a group of spotted hyaena, competition for food can be ferocious and dangerous – the largest and strongest usually getting most of the spoils. Here, a young spotted hyaena sneaks away with the remains of a wildebeest. Hyaena can clean up most of the carcass, leaving only the larger bones, such as the skull and the horn boss.

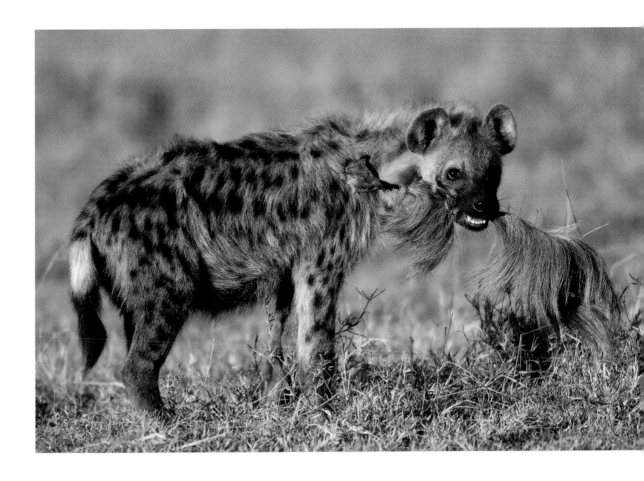

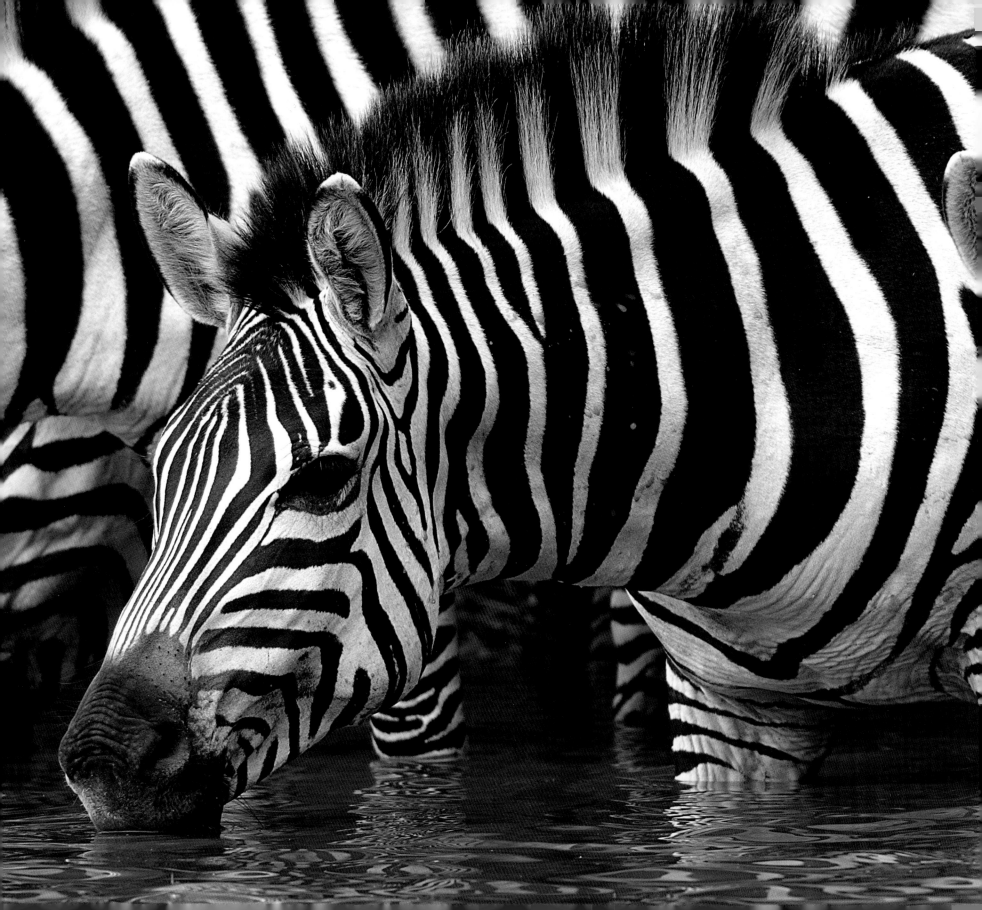

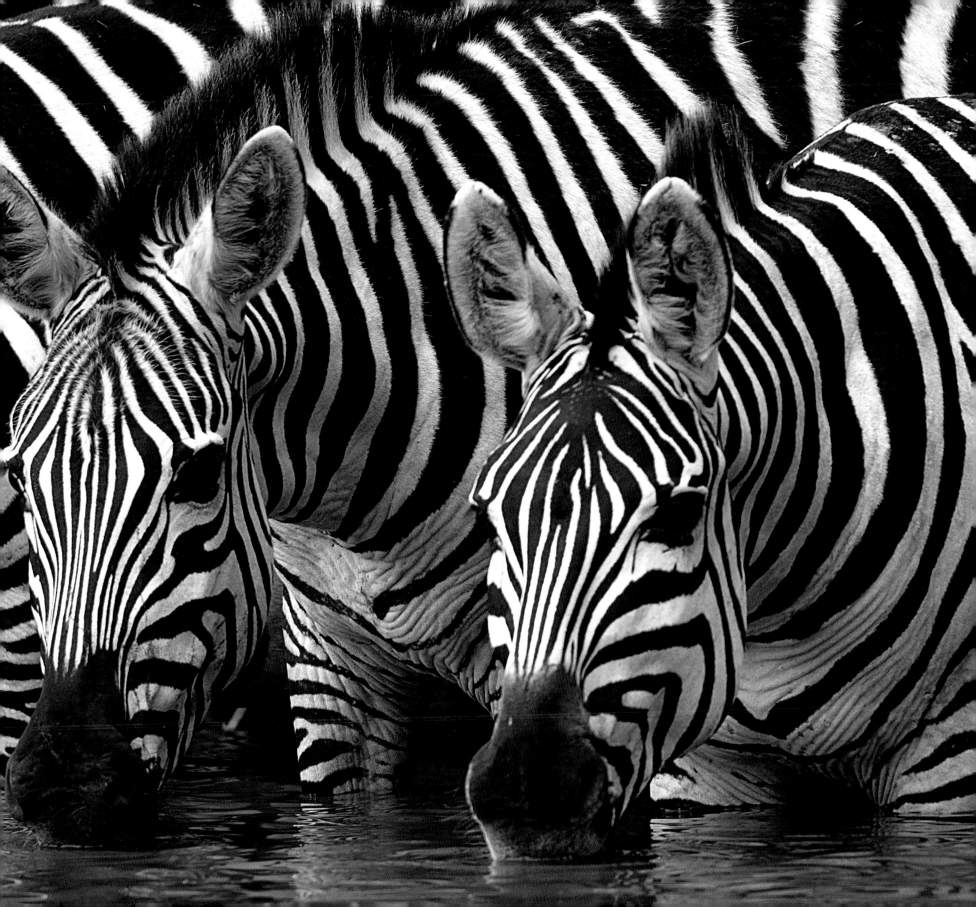

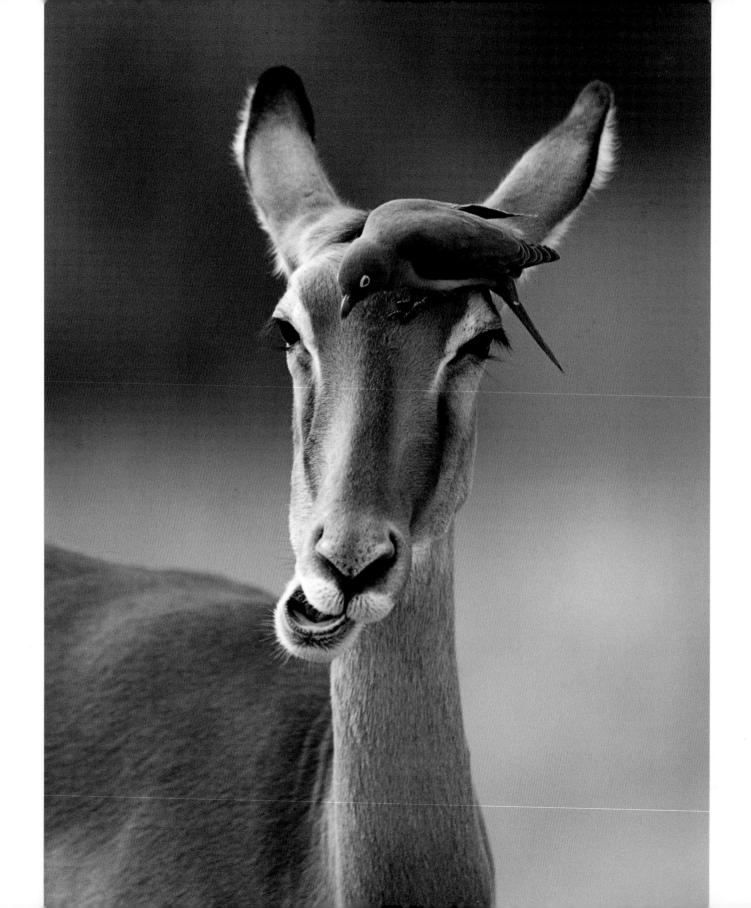

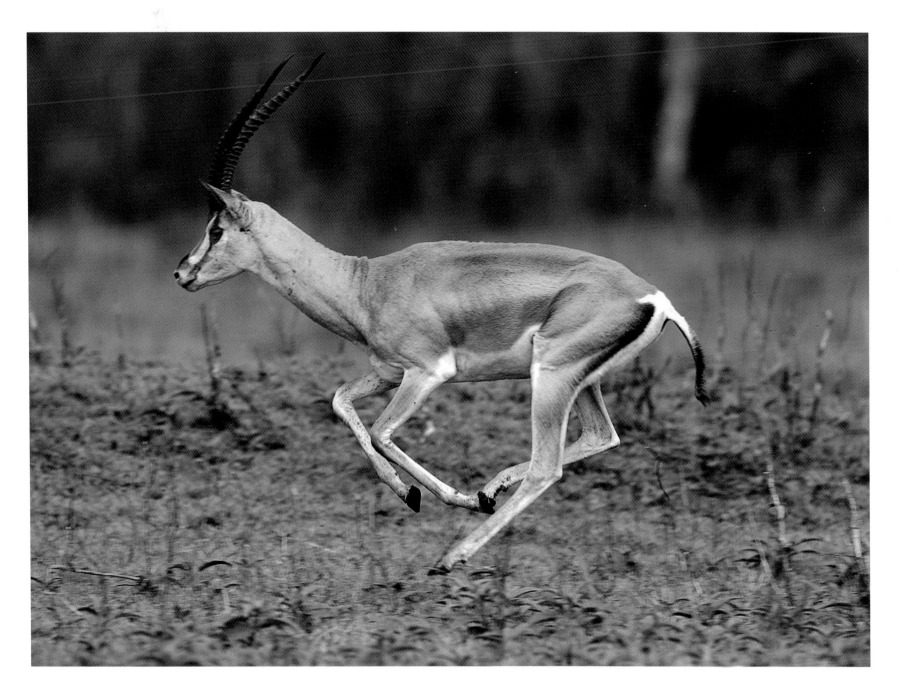

OPPOSITE A Red-billed Oxpecker looks for edibles on the hide of a female impala in Samburu National Reserve, Northern Kenya. The bird will pick off parasites, but may also dip into any open wounds and sores, delaying healing.

ABOVE Grant's gazelle are among the most numerous of East Africa's antelope species, though their numbers do not approach those of the smaller, but similar-looking, Thomson's gazelle.

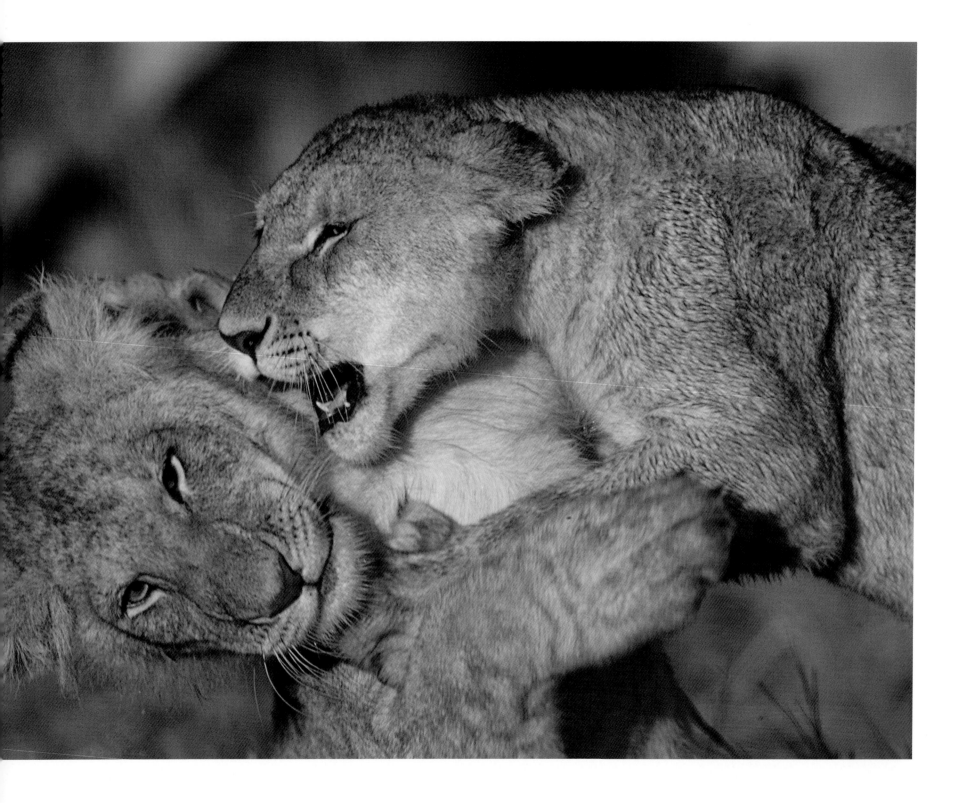

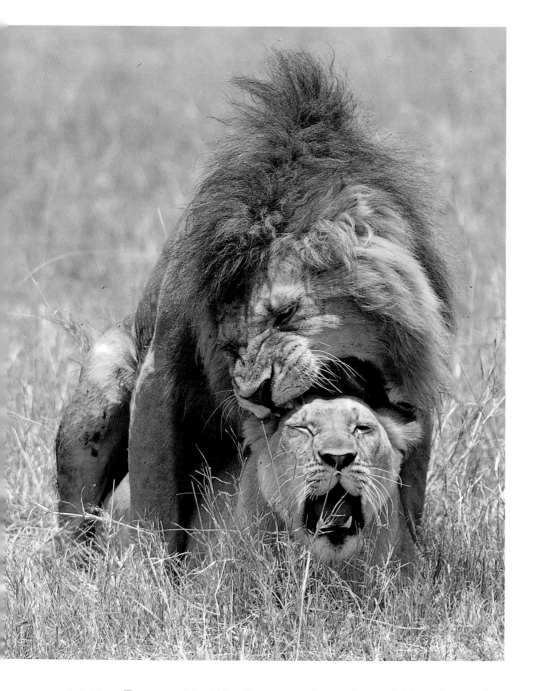

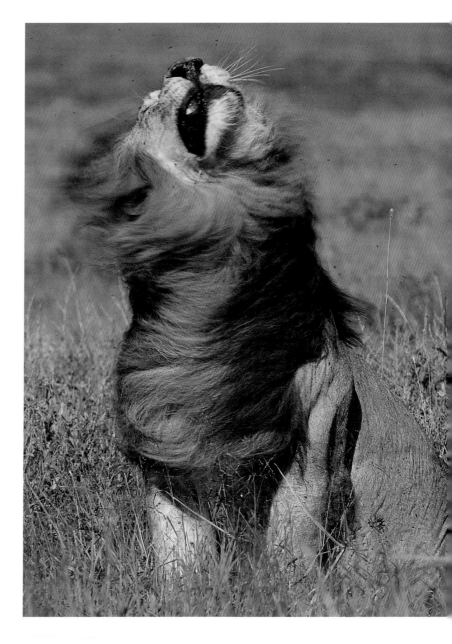

OPPOSITE Two young Masai Mara lions engage in a typical youthful sparring match, behaviour that prepares them for the rough and tumble of adulthood when males must fight for dominance over territory and the resident prides.

LEFT Mating lions snarl and bite at each other as their brief moment of copulation ends. Mating takes place several times an hour over a three- to four-day period.

ABOVE A black-maned Serengeti lion shakes his head and mane vigorously after a brief rain shower.

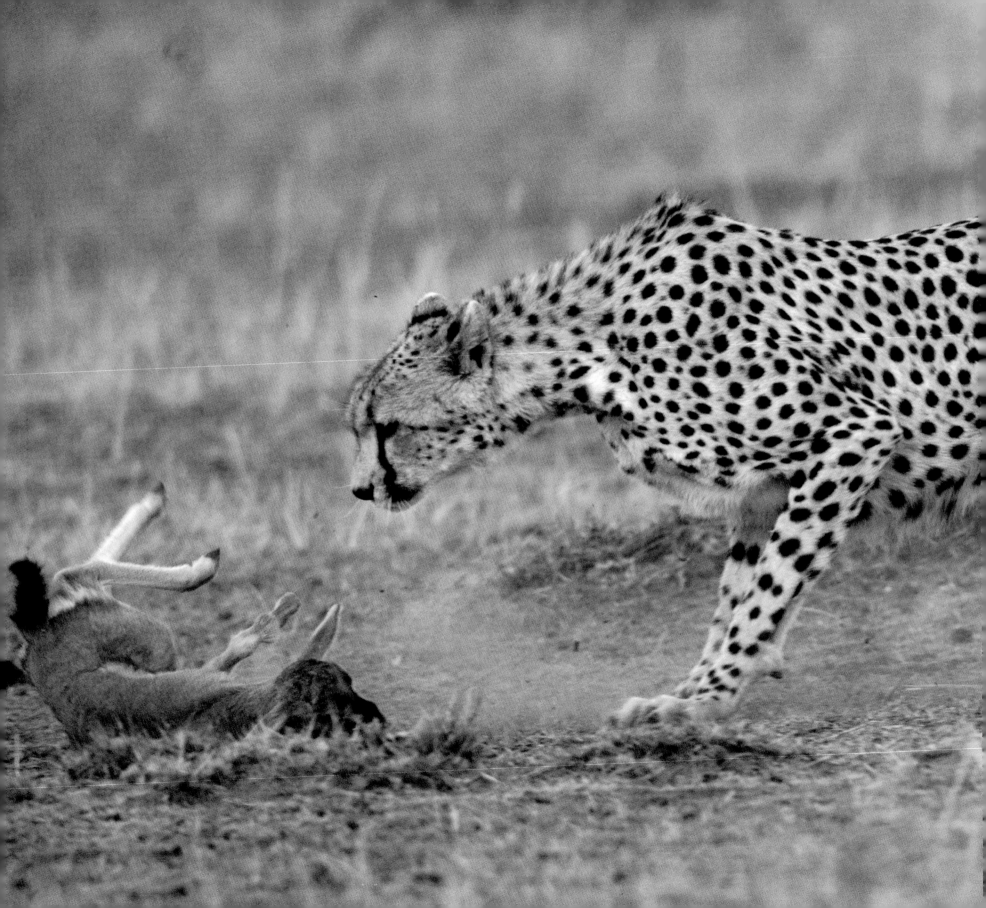

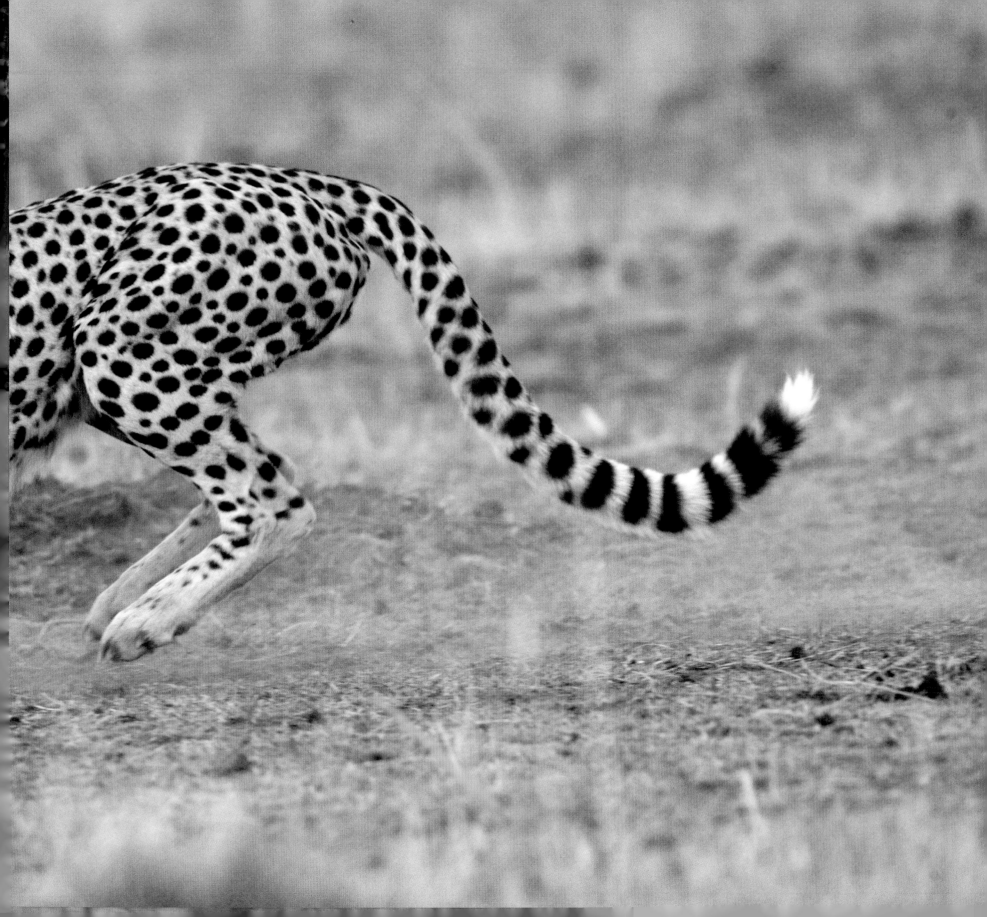

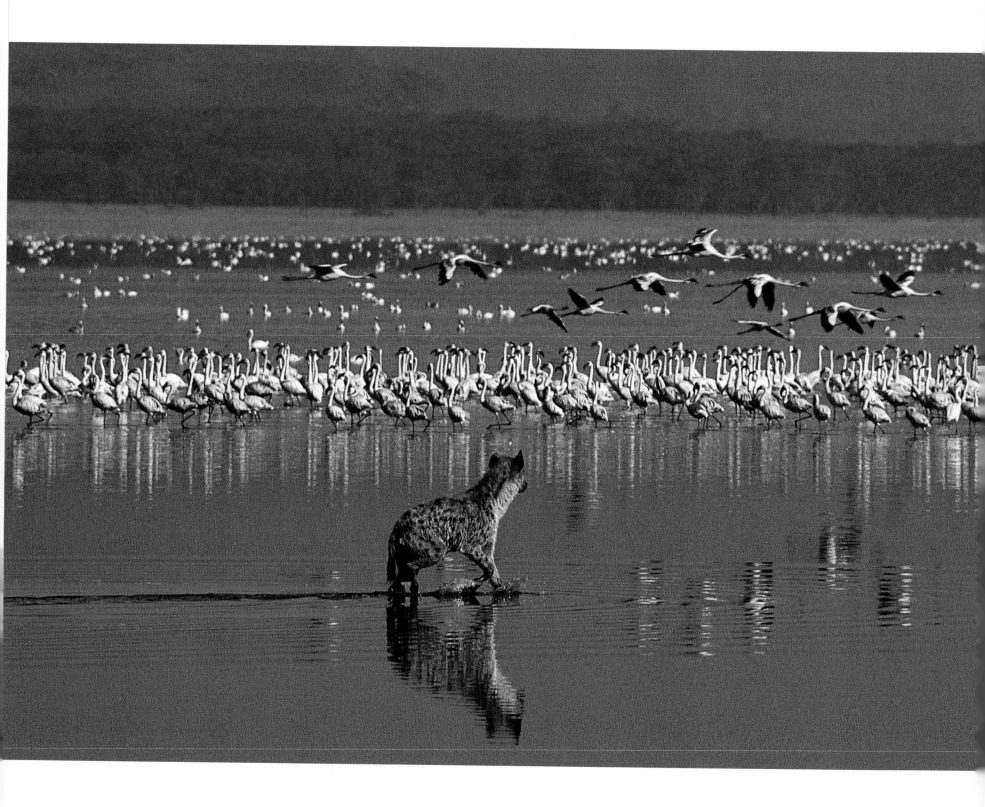

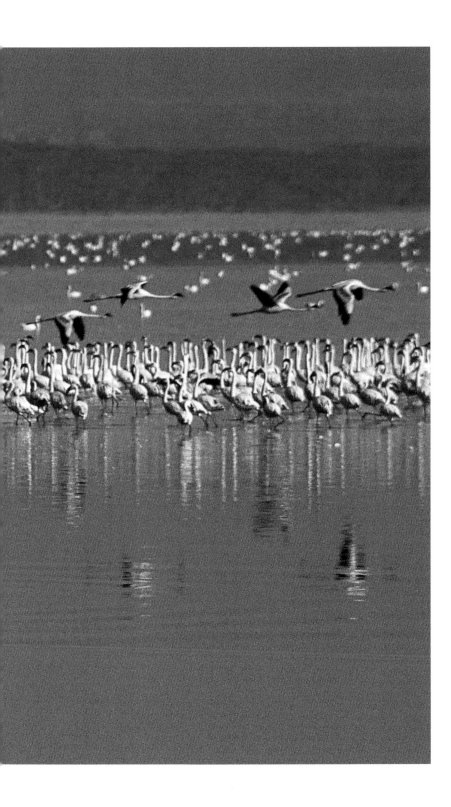

LEFT When feeding conditions are optimal, Lake Nakuru in Kenya carries immense numbers of both Lesser and Greater Flamingos.

BELOW The park has a healthy population of spotted hyaenas that has learnt how to catch straggler birds by running into the flocks that feed close to the shoreline. This individual has scored a meal.

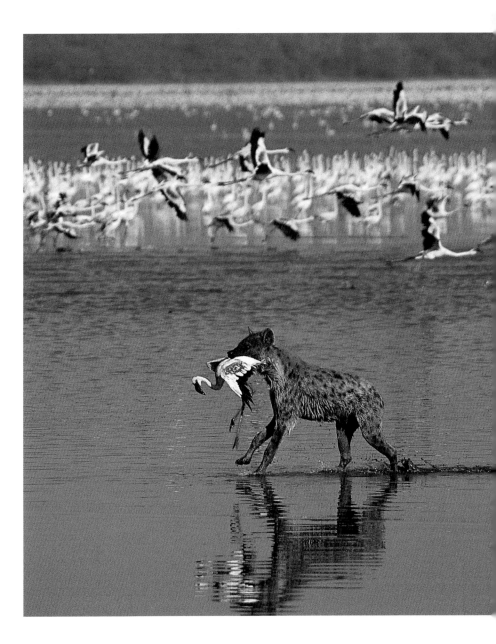

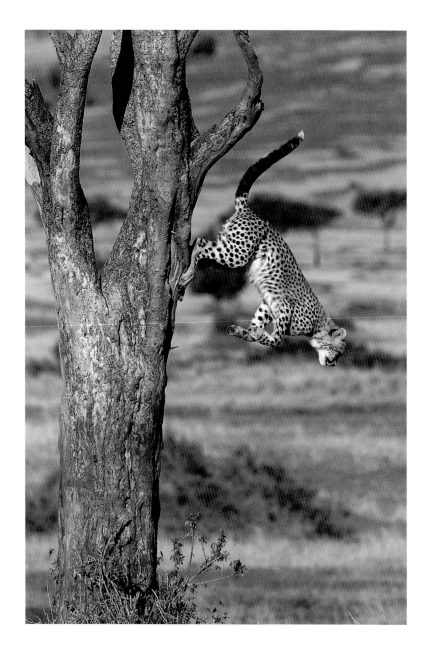

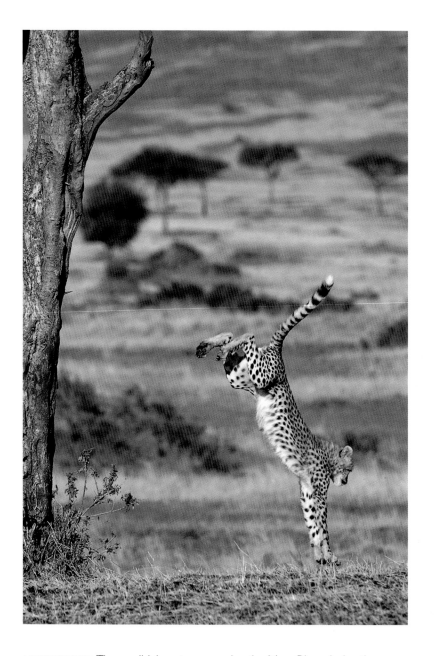

THIS PAGE AND OPPOSITE Female cheetahs are solitary and have litters averaging three to four cubs, which gain independence at about 18 months of age. The cubs are playful in the cooler periods of the day, and trees provide ideal playgrounds and vantage points from which to look out for prey and danger. Having non-retractable claws equips cheetahs with extra grip and speed.

NEXT SPREAD These wildebeest are crossing the Mara River during the annual migration. The need to run great distances, cross rivers and evade predators in the yearly migration means that only the very fittest of these animals survive life in the Serengeti.

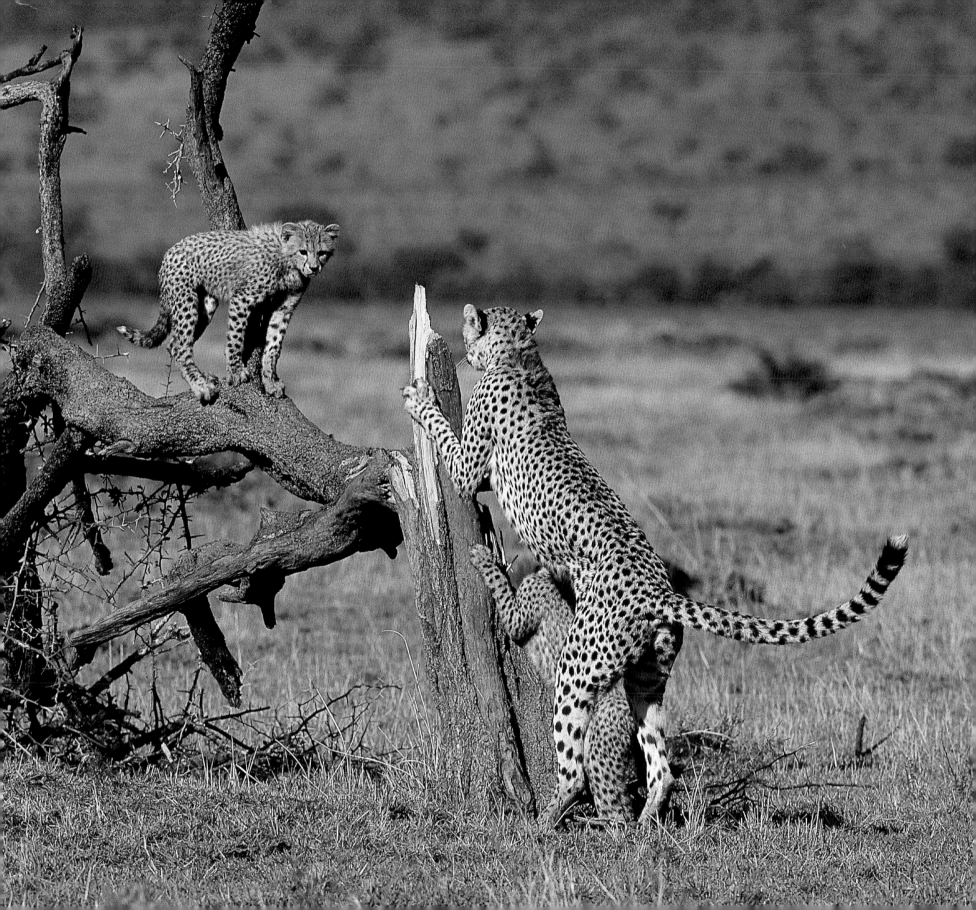

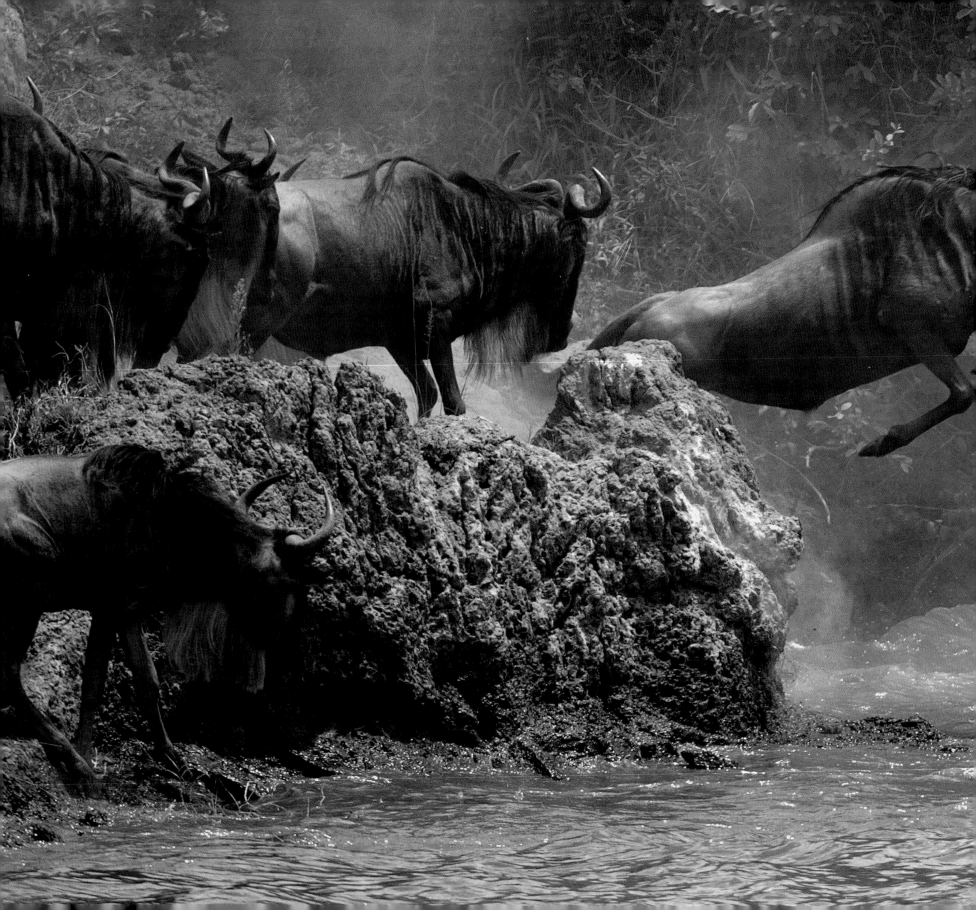

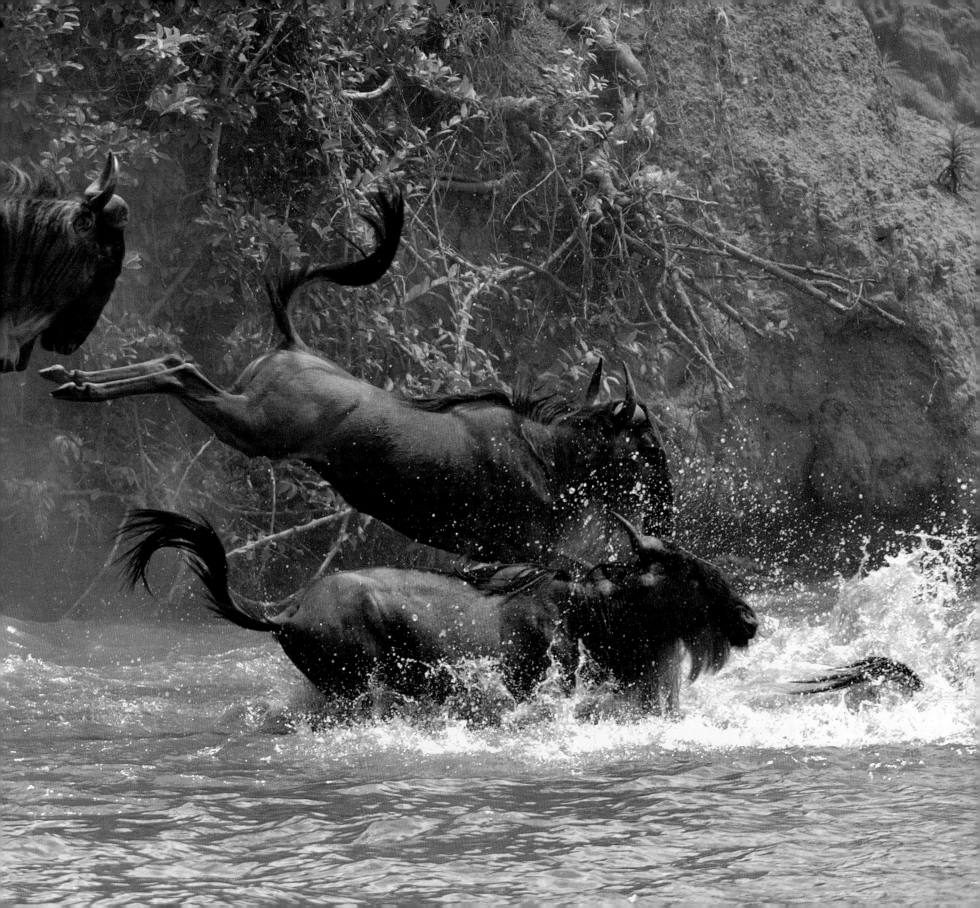

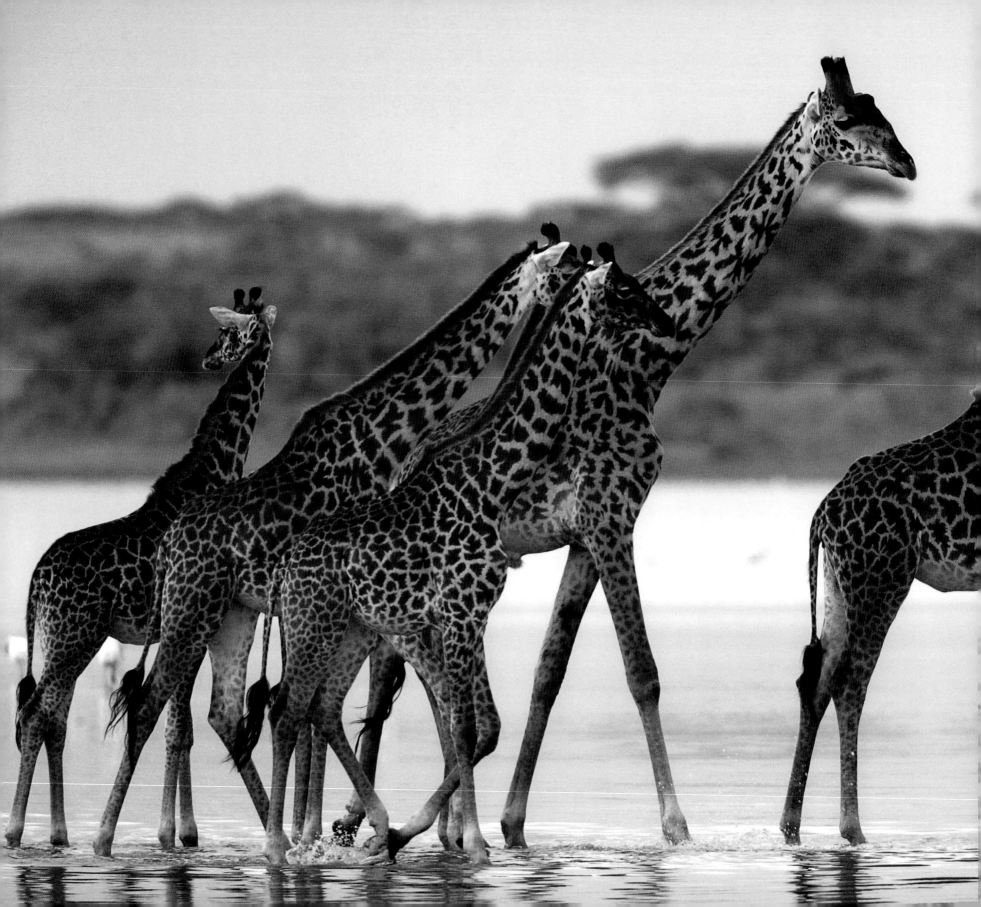

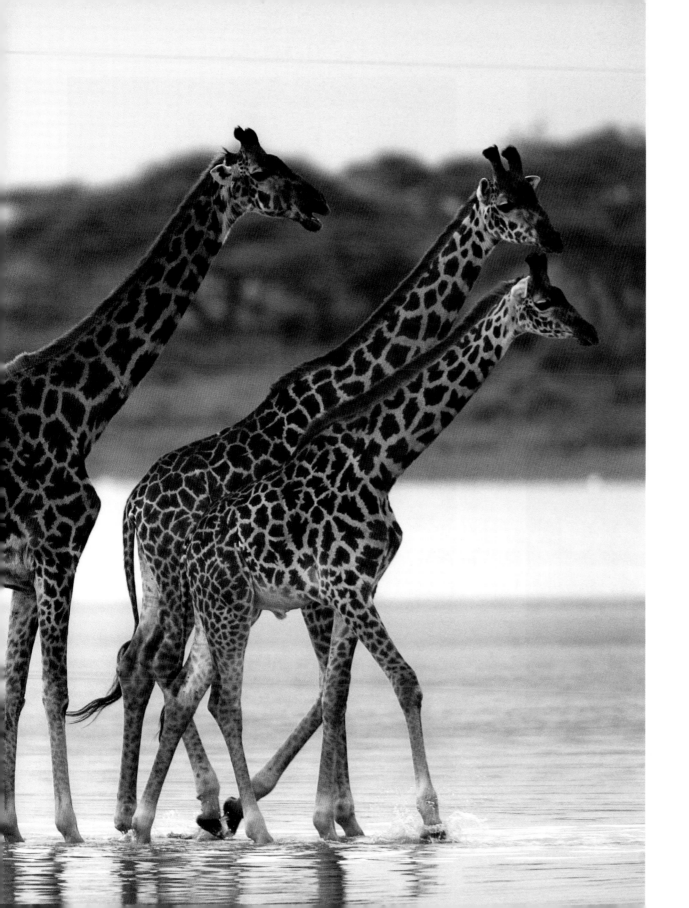

Although giraffes usually run in herds of 4 to 30 individuals, these groupings are relatively unstable and there is considerable movement between herds. The only stable unit is that of cow and calf, with adult bulls spending much of their time alone.

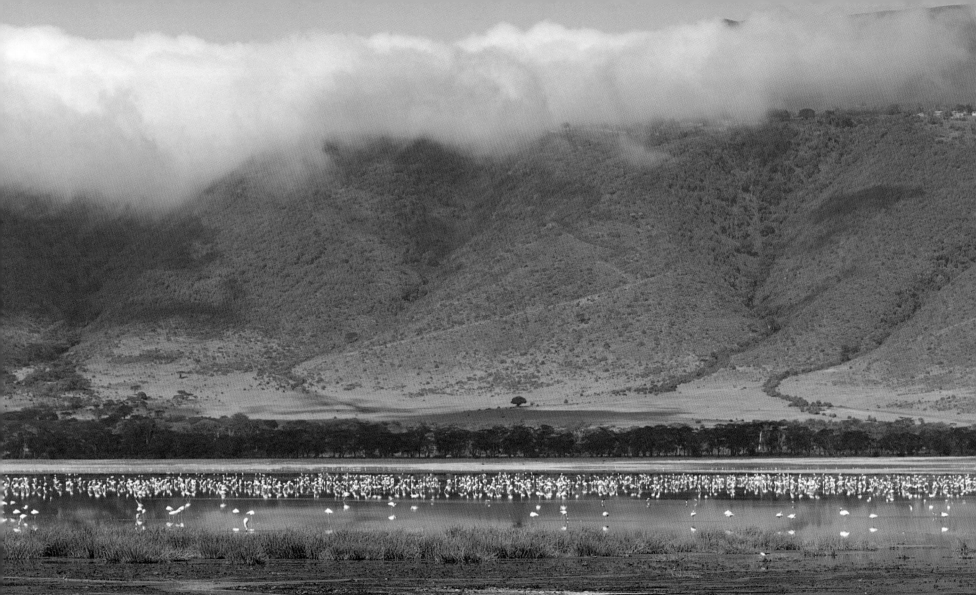
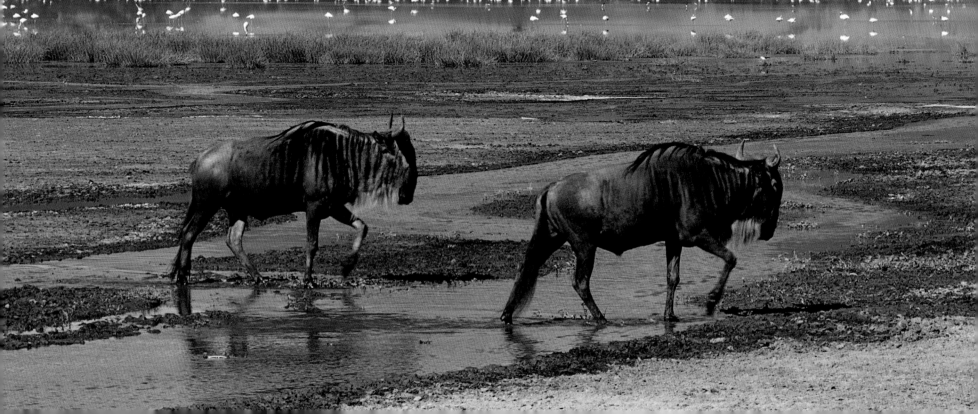

LEFT Two wildebeest walk along the shore of Lake Magadi in the Ngorongoro Crater, Tanzania, in search of new pastures. A large flock of pink flamingos and the dramatic wall of the crater provide the background.
BELOW Thirsty wildebeest line up along the bank of the crocodile-infested river in Serengeti National Park, Tanzania, during their long, dry-season migration.

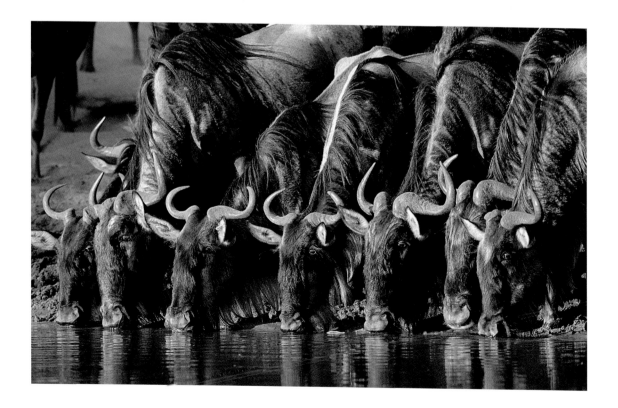

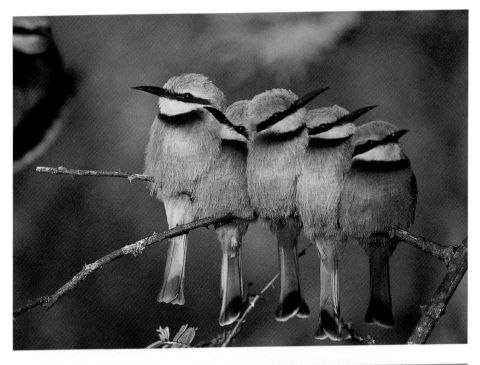

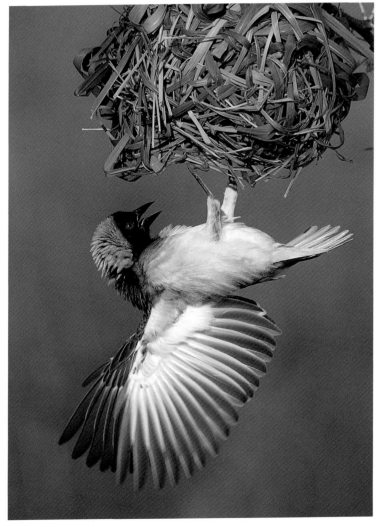

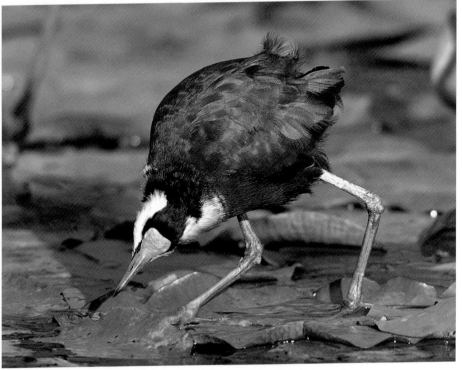

CLOCKWISE, STARTING ABOVE LEFT **Little Bee-eaters** often roost in groups for warmth. They do eat bees, but also other flying insects. Male **Village Weaver** displaying after building a nest of grass strips. If a female accepts the nest she lines it with fine grasses. Females rarely accept the first nest, so males must try repeatedly. An **African Jacana**, carefully lifting the edges of lily leaves with its long toes and beak, checks for insects, aquatic larvae and seeds to feed on.

OPPOSITE This **Southern Ground Hornbill** has captured a large locust in a tree and swoops down to eat it on the ground.

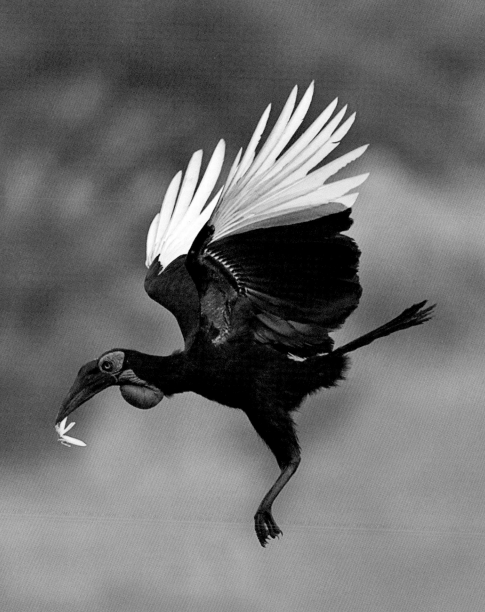

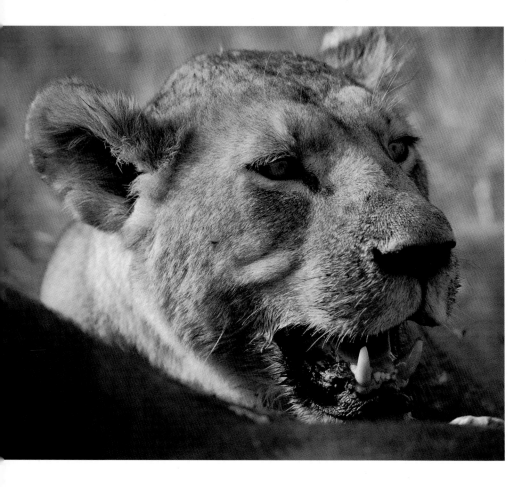

ABOVE A lion feeds on a buffalo that has been killed by the pride.

RIGHT A resting male lion grimaces in annoyance when a pride cub attempts to nuzzle him, Masai Mara National Reserve, Kenya.

NEXT PAGE LEFT A hippo 'yawns' in the late afternoon just before leaving the water to forage for food. The yawn is actually a threat display mostly given by males to warn other males nearby. A yawn exposes the hippo's two formidable forward-pointing tusks (incisors) and its sharp canines. Young males also frequently challenge each other by yawning, while females yawn when defending their young.

NEXT PAGE RIGHT Although known to cause more deaths in Africa than any other mammal, hippos often appear comical, and their harrumphing snorts while resting in rivers and waterholes by day will usually raise a chuckle among observers. This bull, adorned with water lettuce, looks far from dignified or frightening!

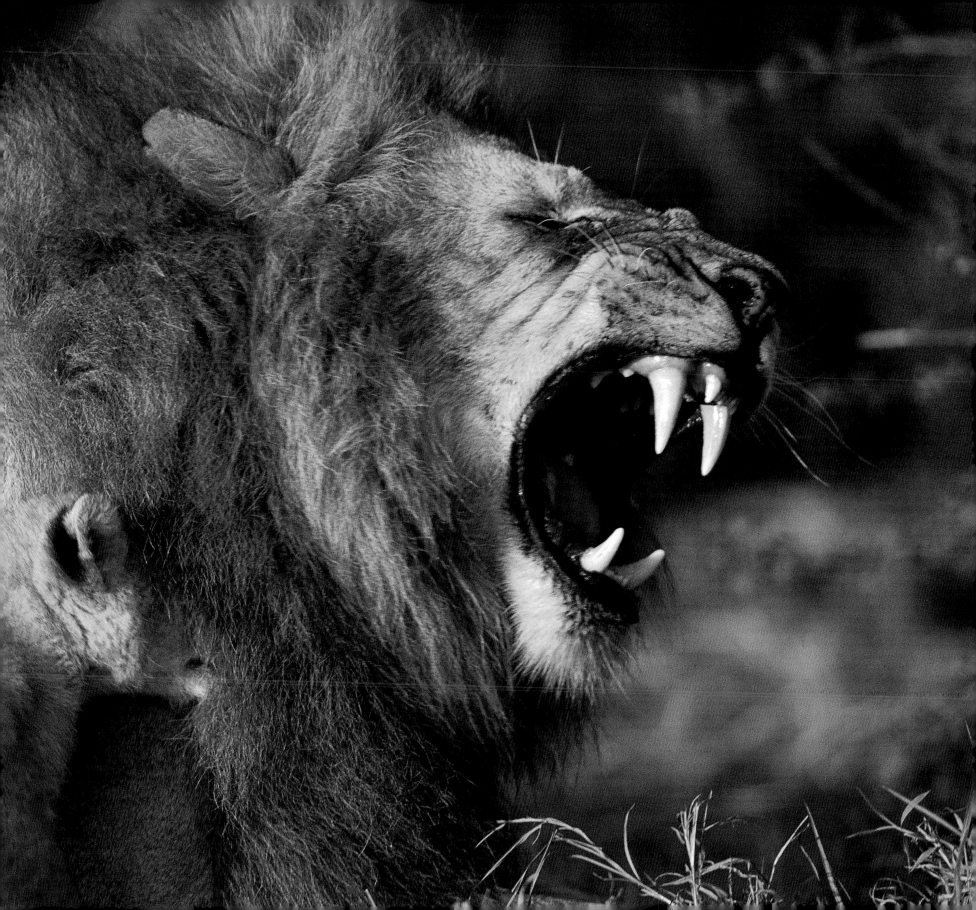

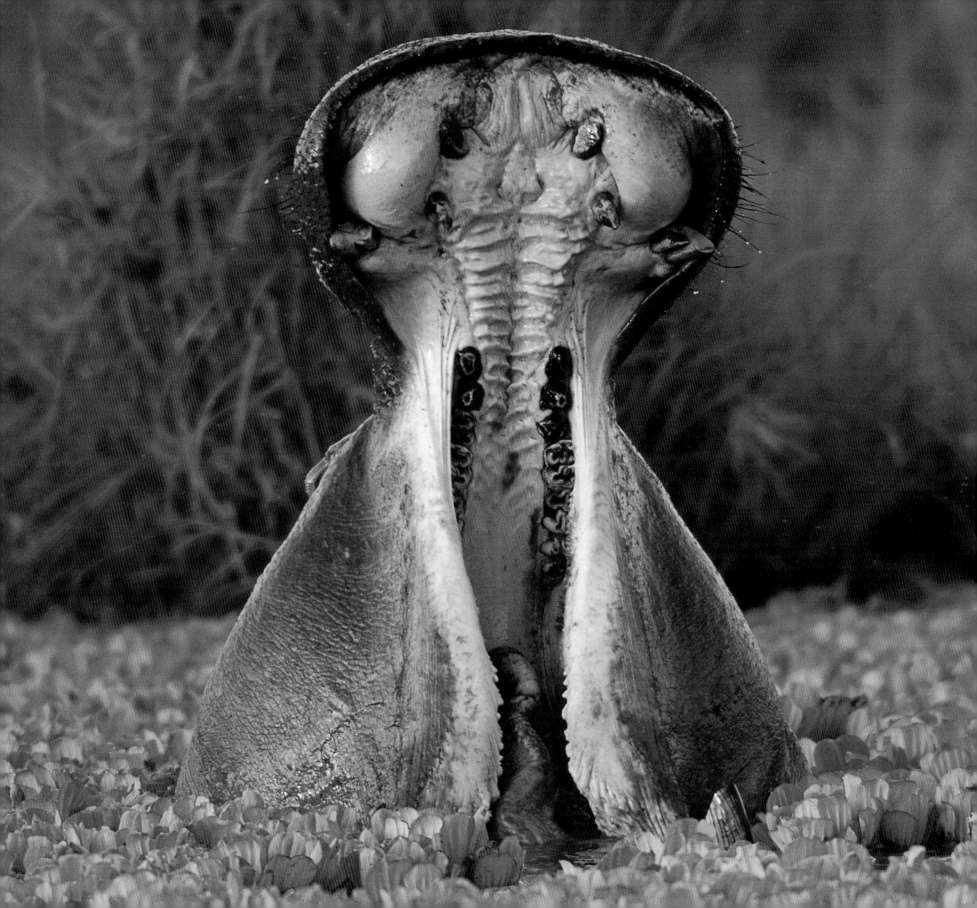

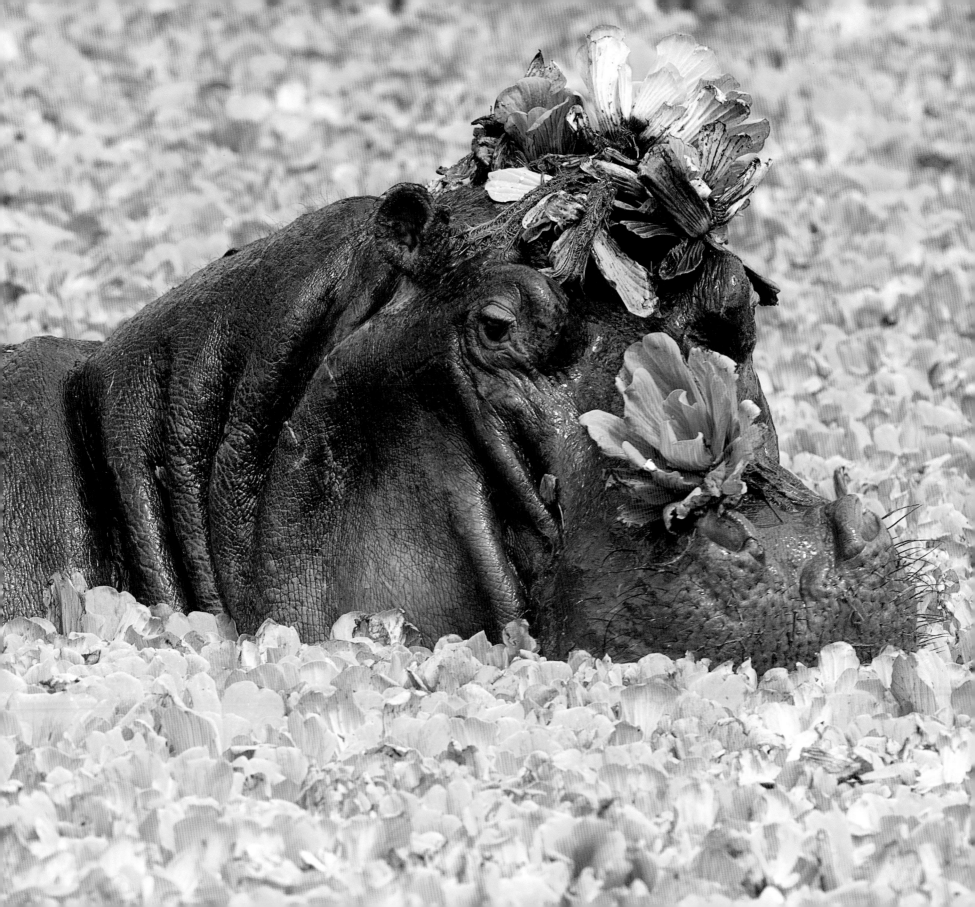

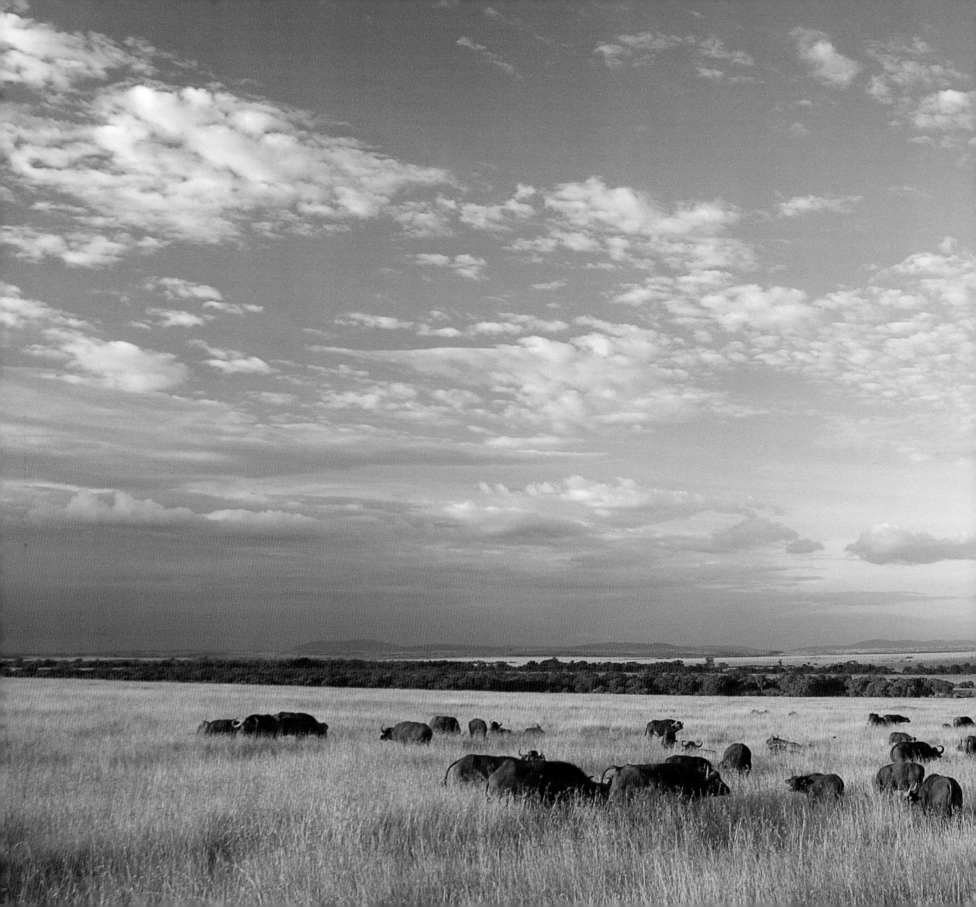

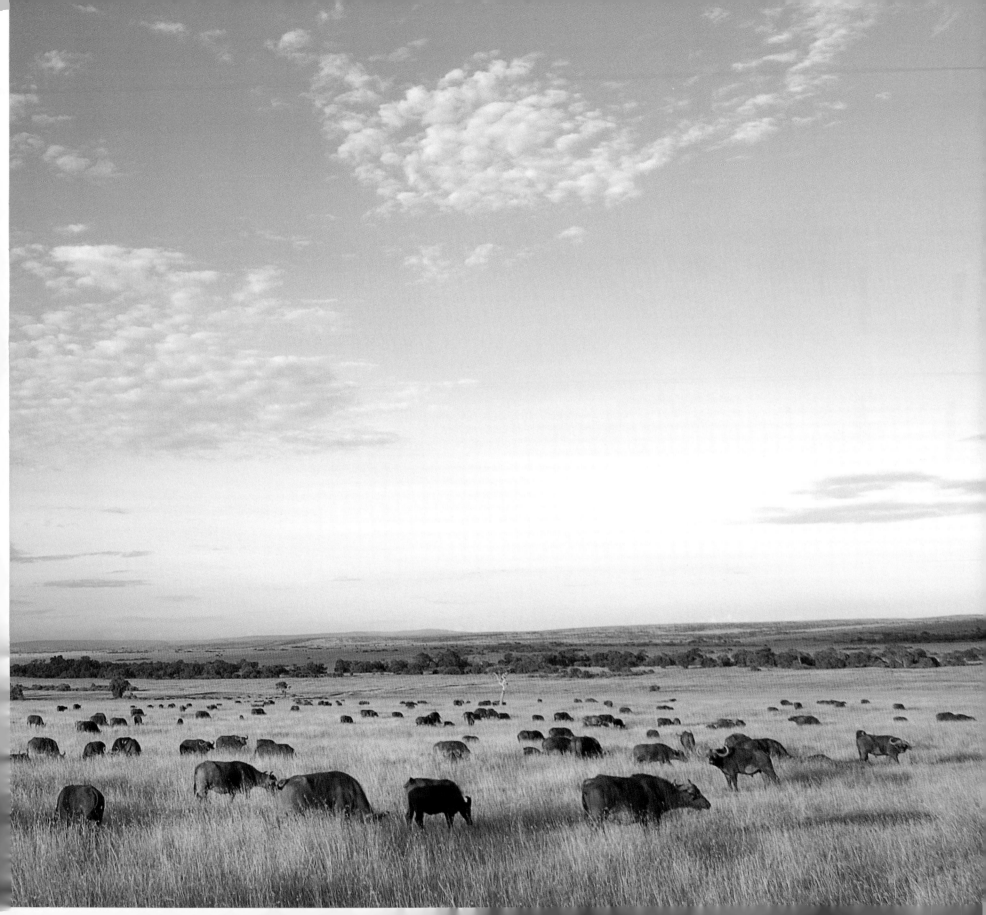

BELOW Lions in a pride warn each other with facial gestures as they compete for their share of buffalo calf meat. The calf was brought down mid-morning in Katavi National Park, Southern Tanzania.

RIGHT This photograph was taken at Ndutu in the Serengeti Plains. The kill is a few hours old and the cub is still trying to get some leftovers, the leaders of the pack having had their share. Male lions usually feed first and what is left goes to the rest of the pride.

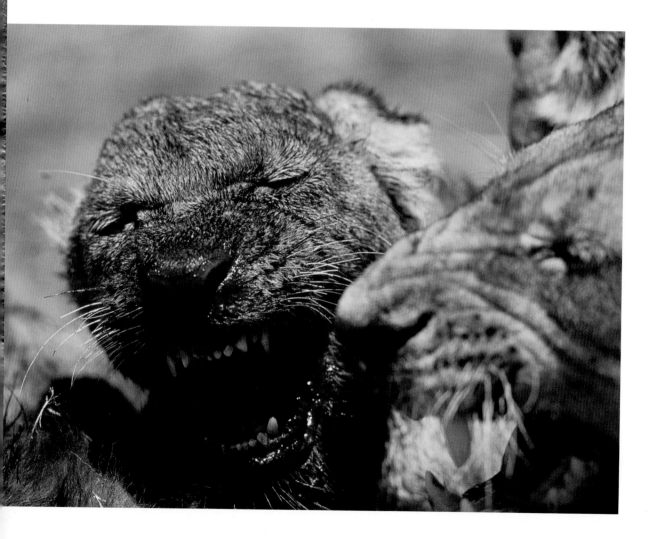

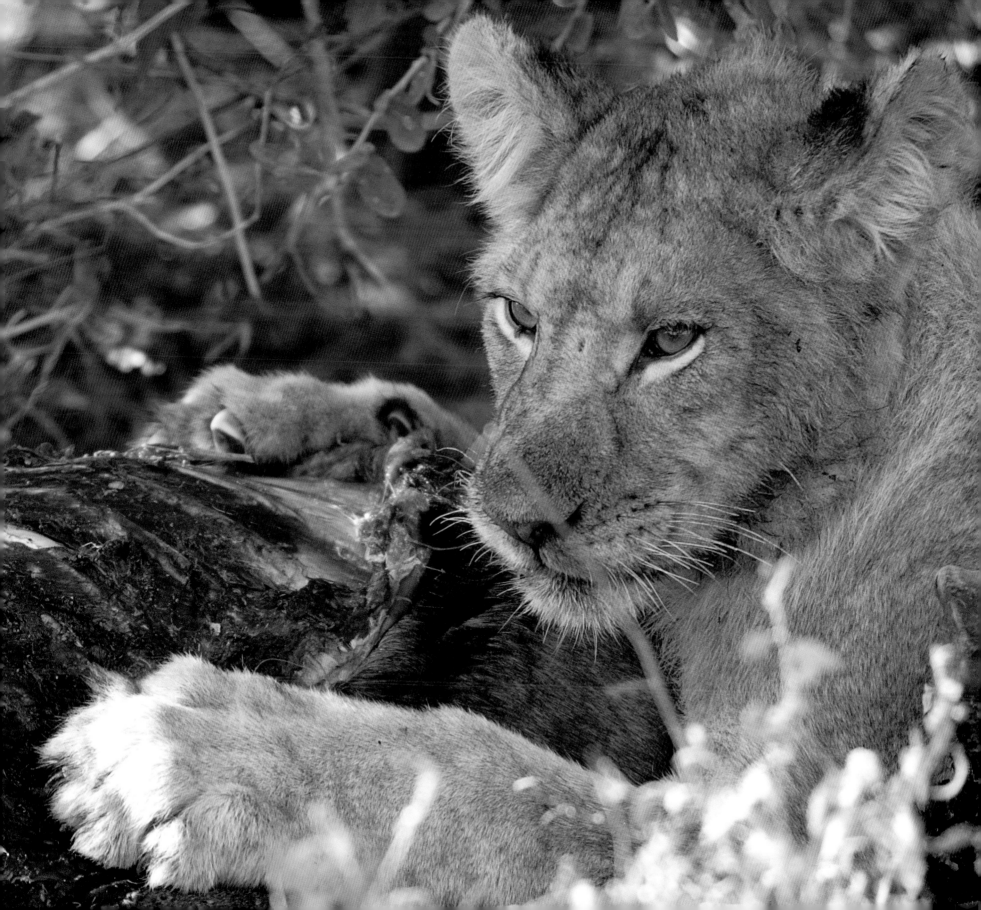

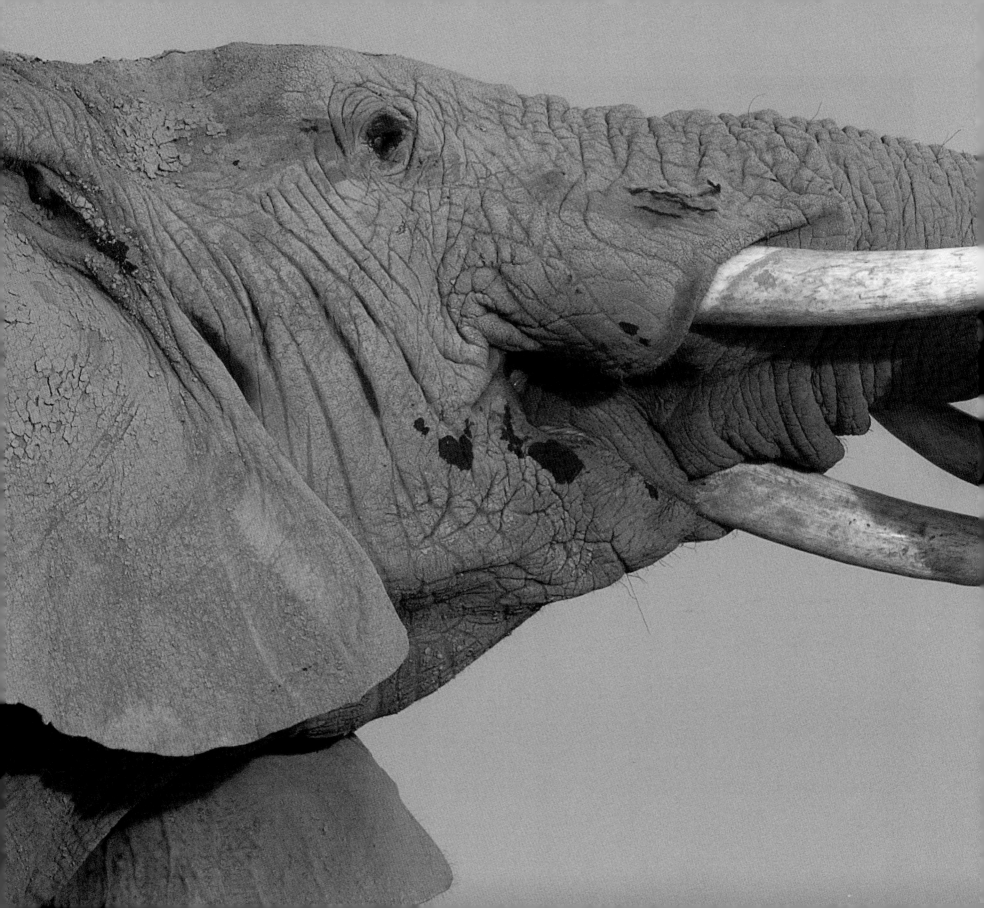

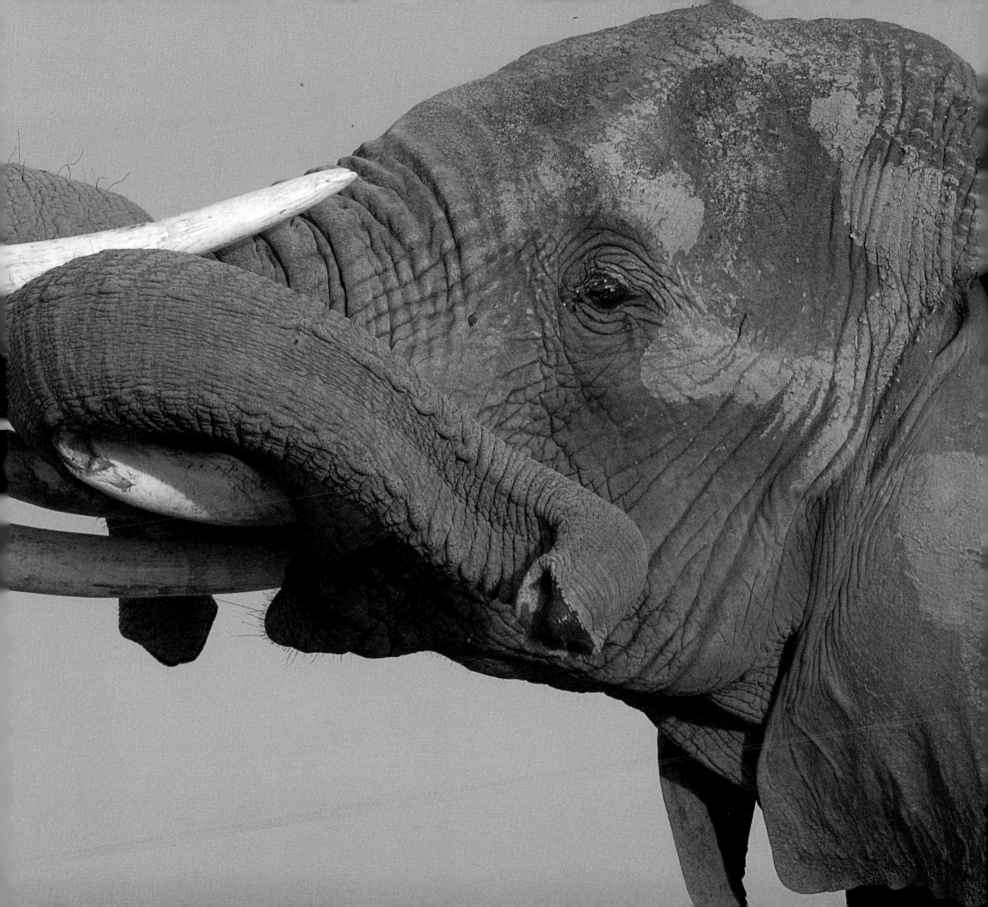

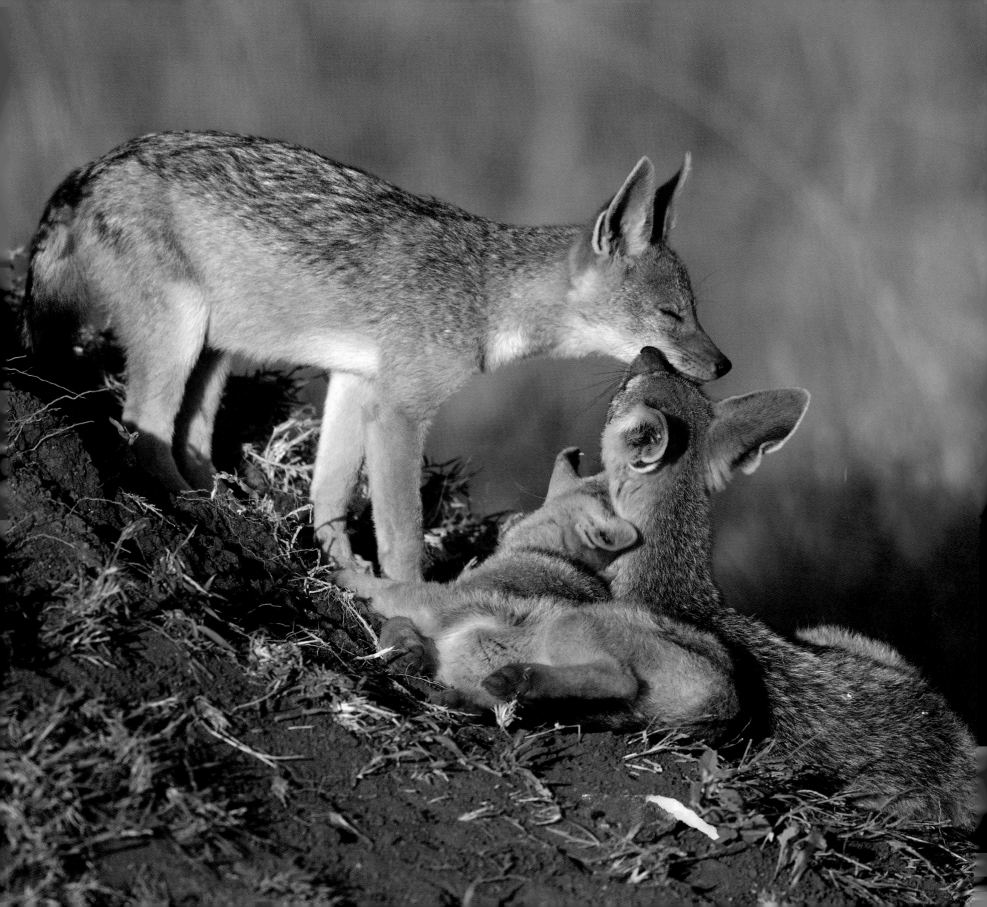

PREVIOUS SPREAD Young bull elephants in Amboseli National Park test each other in play fighting. This mimics the behaviour they will perform in all seriousness when they reach adulthood and have to assert their dominance to mate with females in oestrus.

OPPOSITE Black-backed jackal littermates greet one another while lying in the early morning sun outside the entrance to their termite-mound den.

BELOW This bat-eared fox is grooming its pup. At dawn and dusk these nocturnal foxes sun themselves at the entrances of their burrows and can often be seen grooming each other and, particularly, their young. Their main diet consists of harvester ants, termites and beetles but, occasionally, scorpions, birds' eggs and the young of ground-nesting birds are taken. They are found in acacia woodland and dry open country, usually where harvester ants occur.

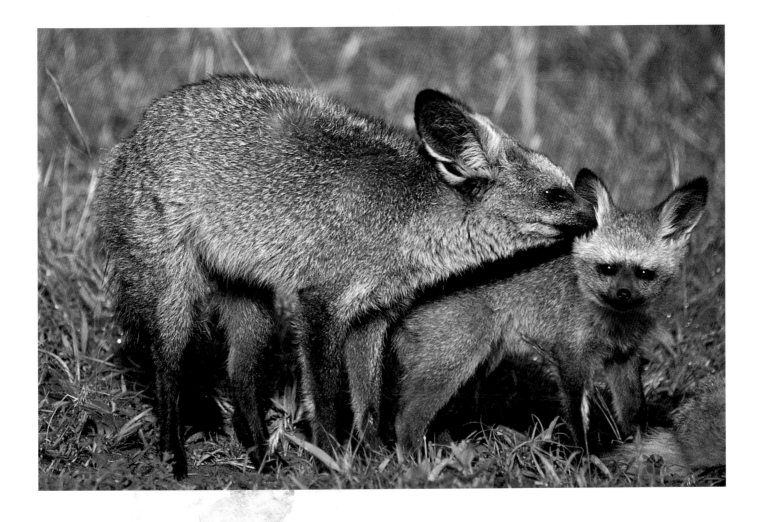

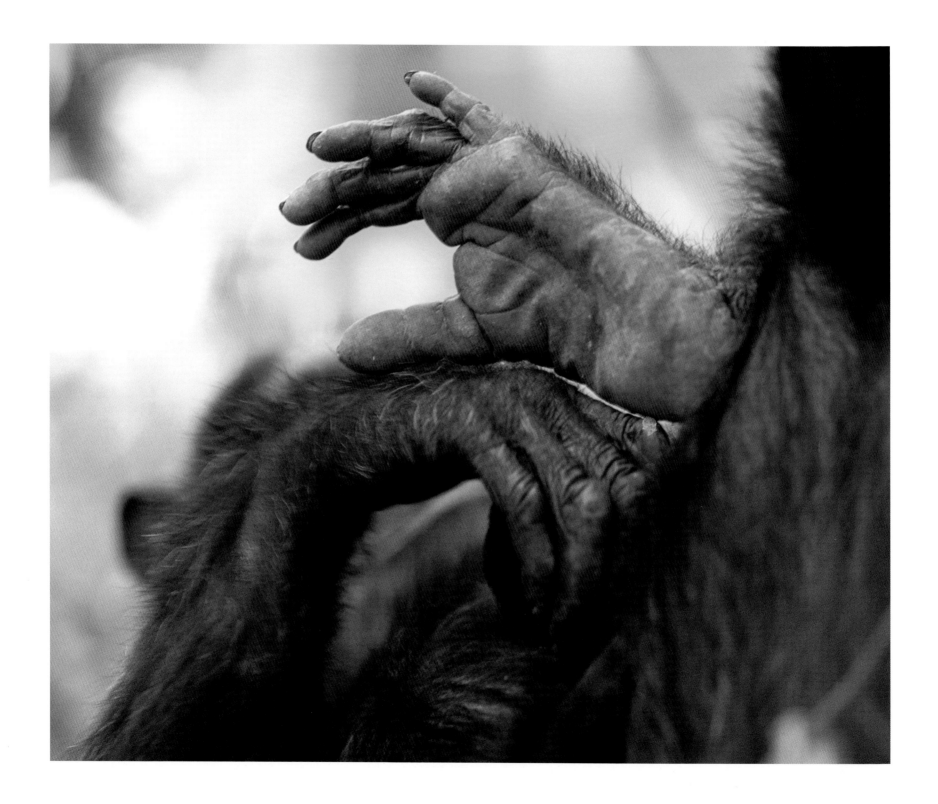

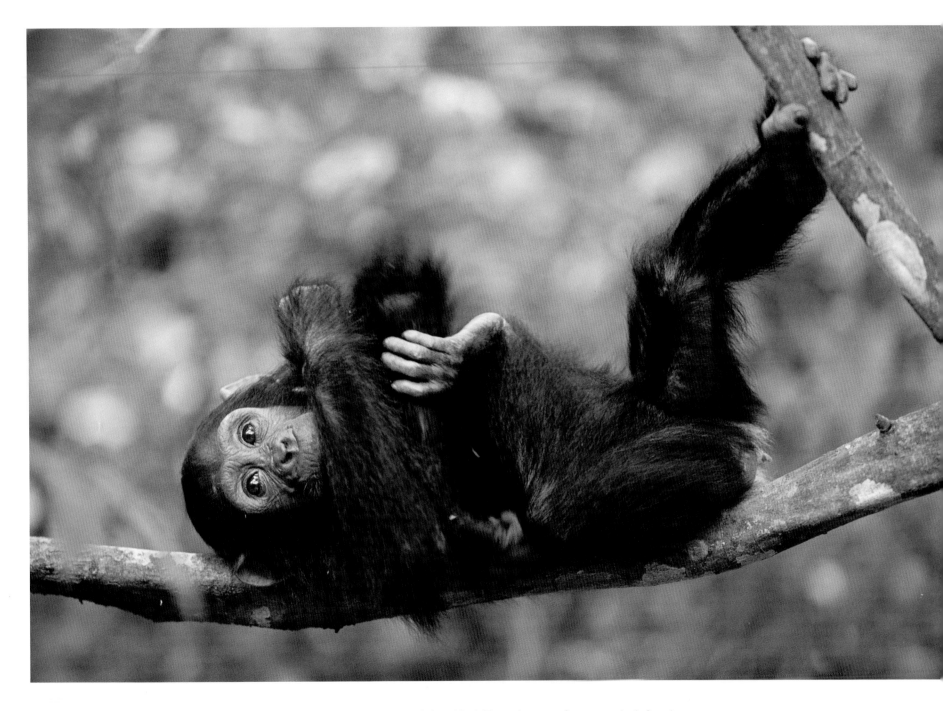

OPPOSITE Fifi, the 45-year-old common chimpanzee matriarch at Gombe National Park, Tanzania, rests after a morning's foraging.

ABOVE Fifi's juvenile daughter, Flirt, entertains herself on a convenient branch overhead, while her mother rests below.

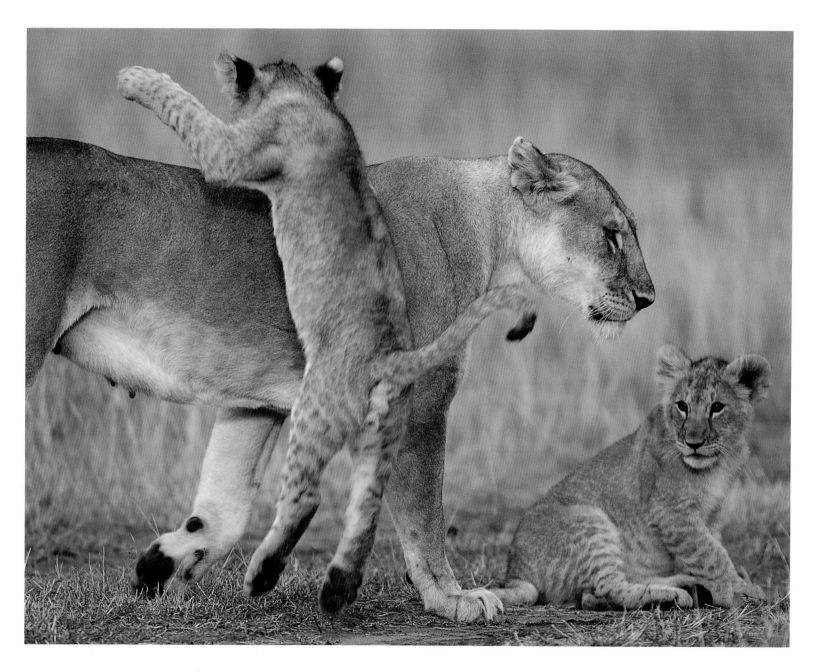

ABOVE AND OPPOSITE Lions are social cats and the family bonds are tight, particularly among females and their offspring. Lionesses are tolerant of the antics of young cubs, which consider adults to be large playmates.

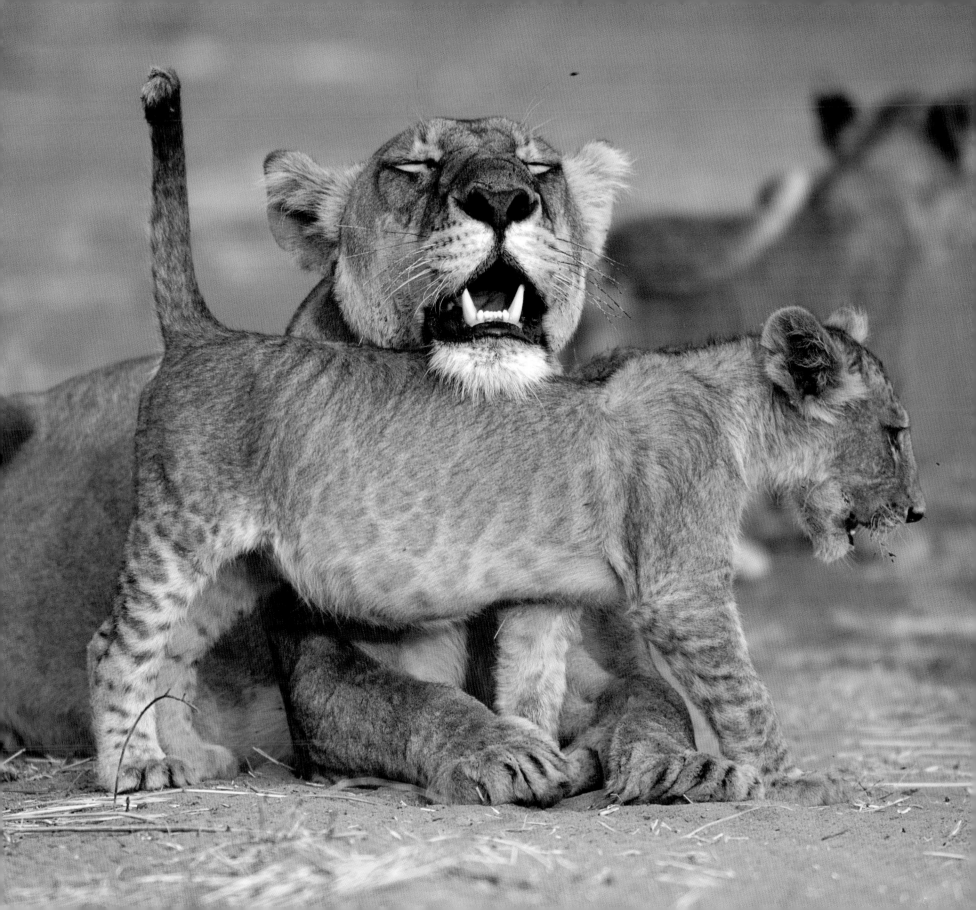

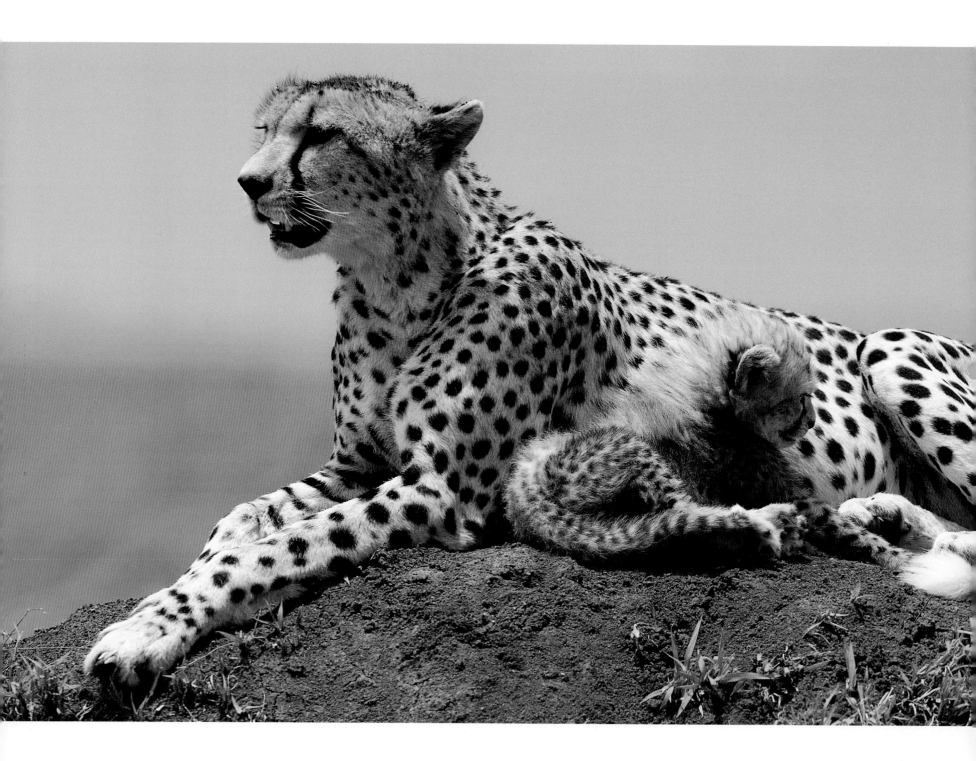

LEFT Female cheetahs give birth to litters of between one and five cubs. The young have an extensive mantle of longish grey hair.

BELOW This cheetah shows the well-developed canines typical of all modern cats. Like all true carnivores, cheetahs also have carnassials, modified molars that slide closely past one another to slice off chunks of meat. To employ these teeth, cats have to turn their heads to the side when eating.

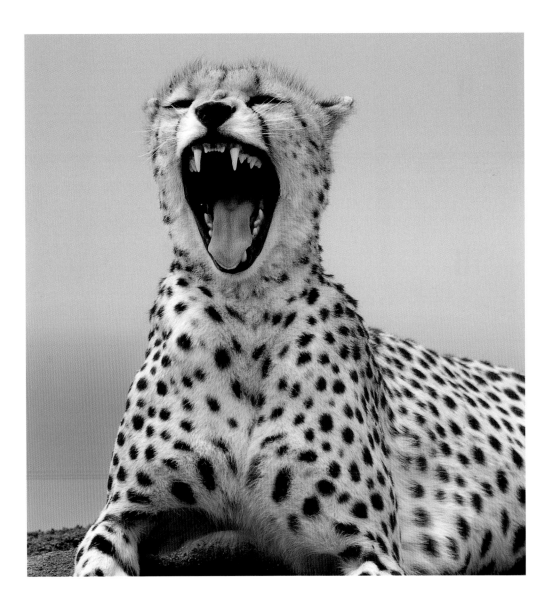

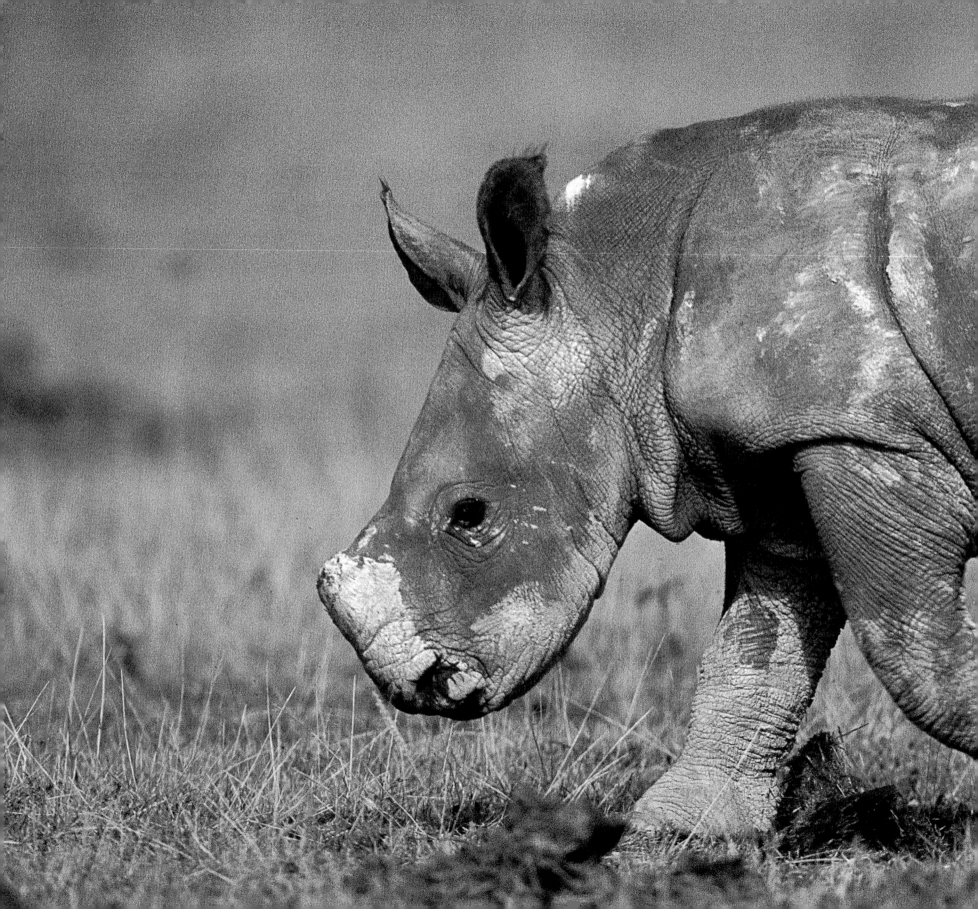

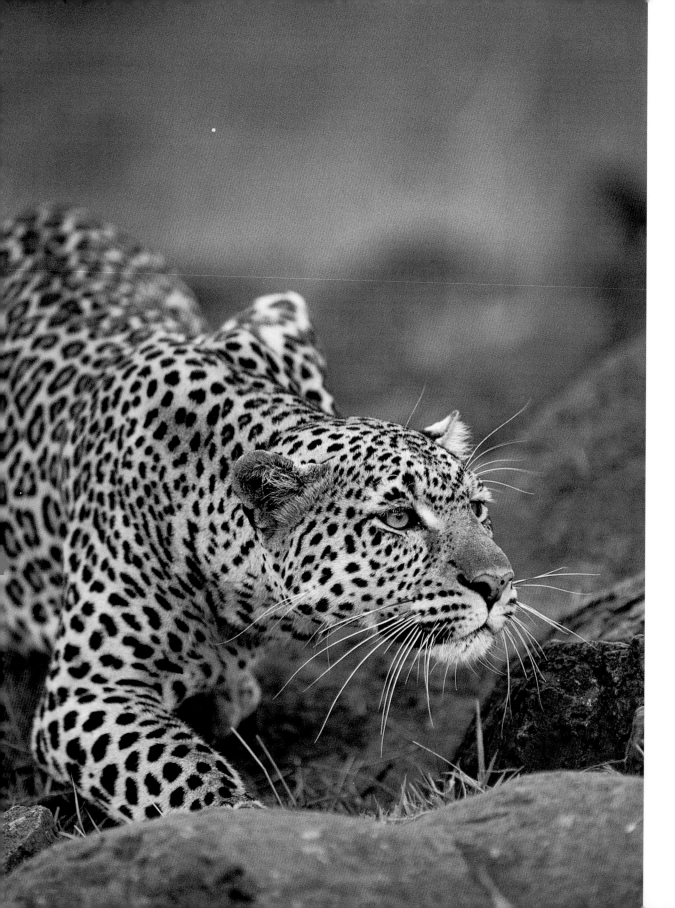

PREVIOUS SPREAD A baby white rhino makes its way to its grazing mother nearby, after frolicking by itself. Early morning, Lake Nakuru National Park, Kenya.

LEFT Half-tail, the famous female leopard featured in several BBC TV documentaries filmed in the Masai Mara National Reserve, Kenya, stalks an impala with intense concentration.

OPPOSITE Shadow, daughter of Half-tail, snarls a warning to a passing spotted hyaena in Masai Mara National Reserve, Kenya. Shadow, a mother herself, has also featured in BBC documentaries.

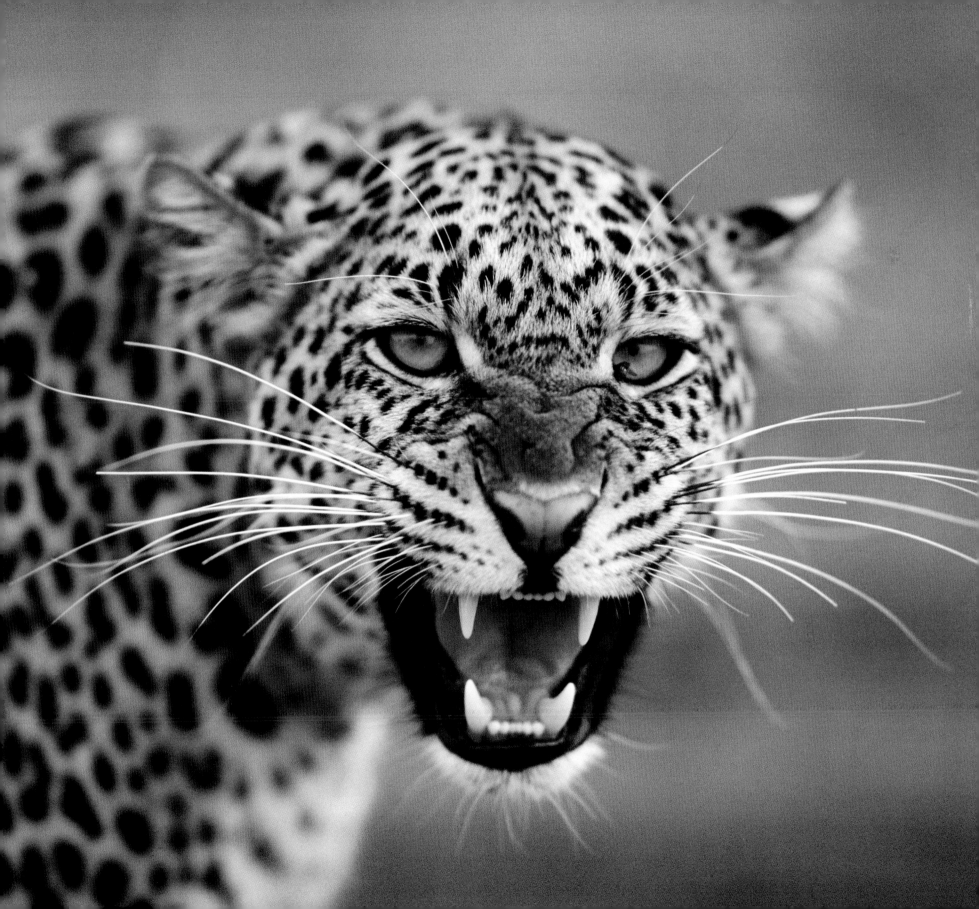

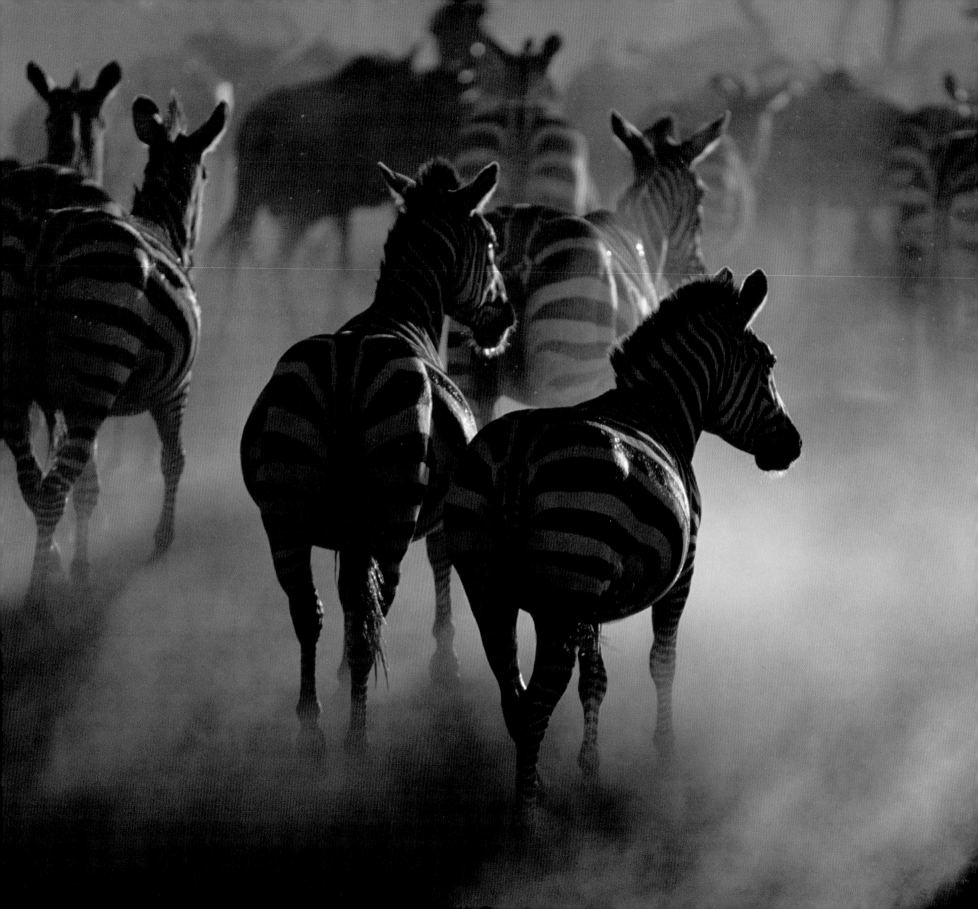

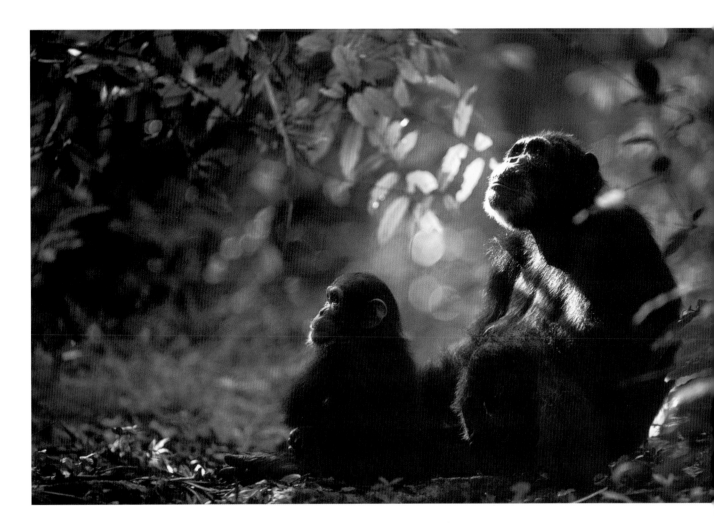

LEFT Dry season, Serengeti National Park, Tanzania. These zebra poured into a drying pool, drank, stomped it into mud and then rushed out in alarm before looking back to assess the situation – a false alarm.

ABOVE A mother and baby chimpanzee relax in the dense forest on the shore of Lake Tanganyika in Gombe Stream National Park, Tanzania. It was at Gombe Stream that Jane Goodall conducted her well-known study of these fascinating animals.

NEXT SPREAD A black rhino (left) encounters two white rhinos at Lake Nakuru National Park, Kenya. Although black rhinos are significantly smaller than their white counterparts, they are the more dangerous of the two species.

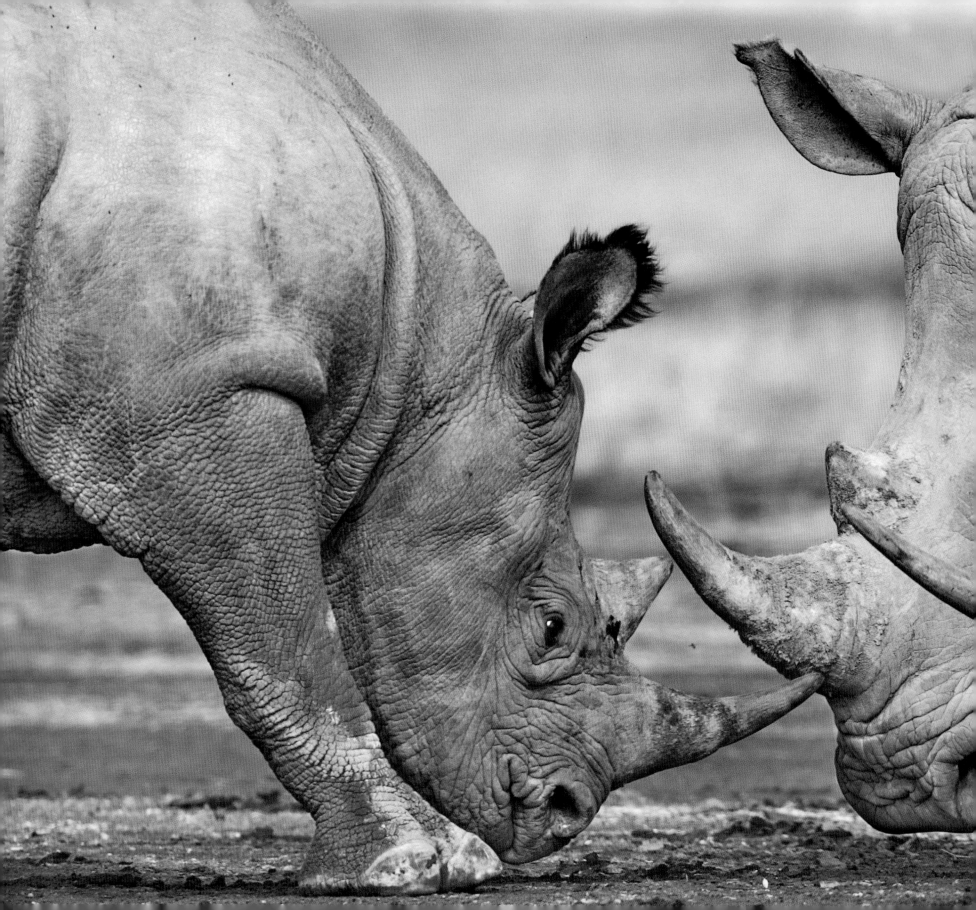

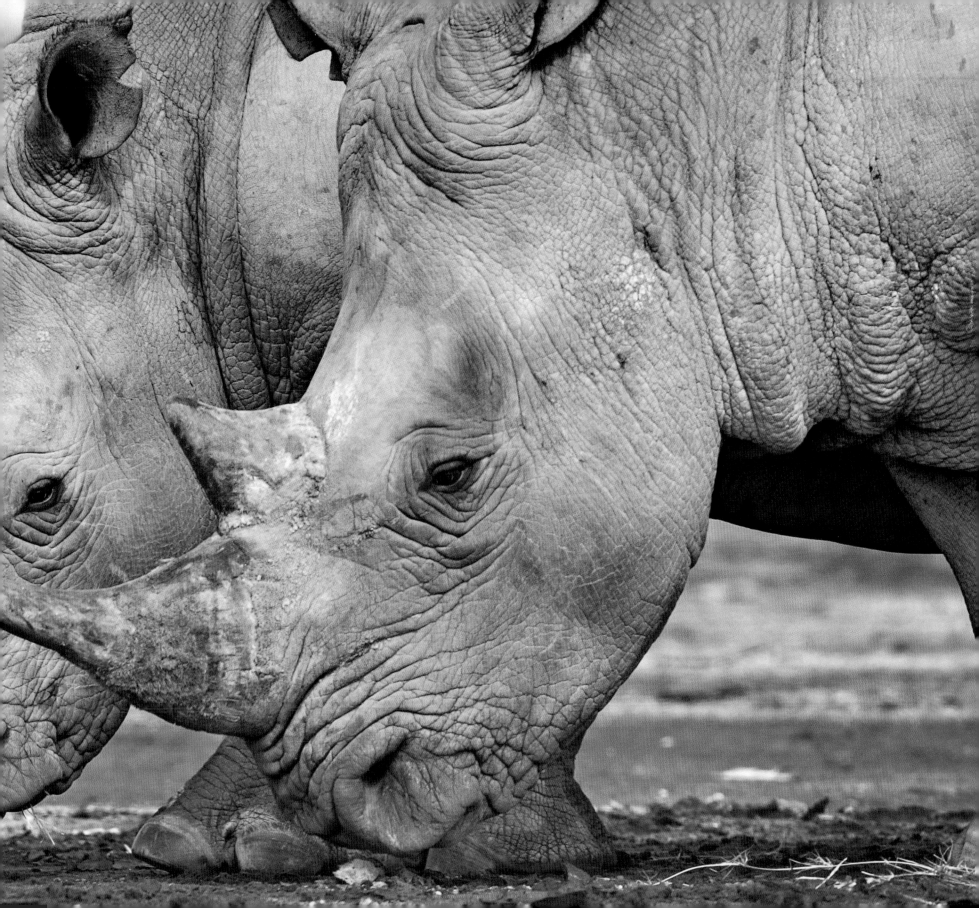

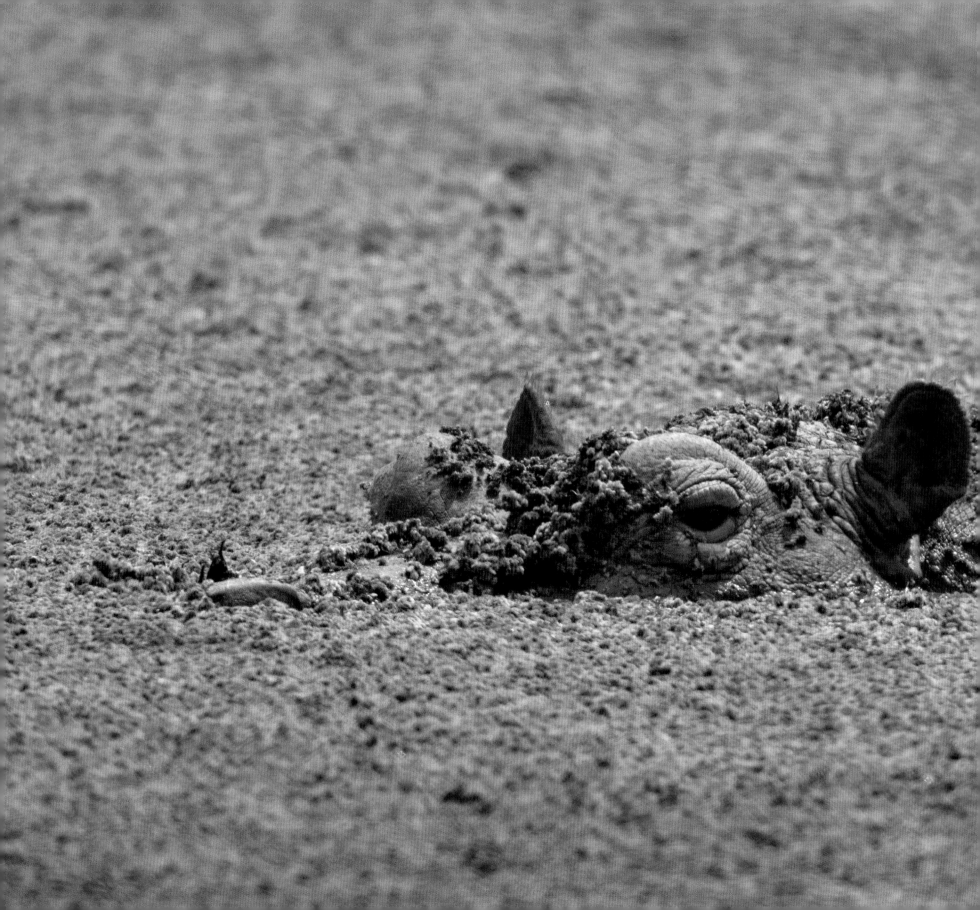

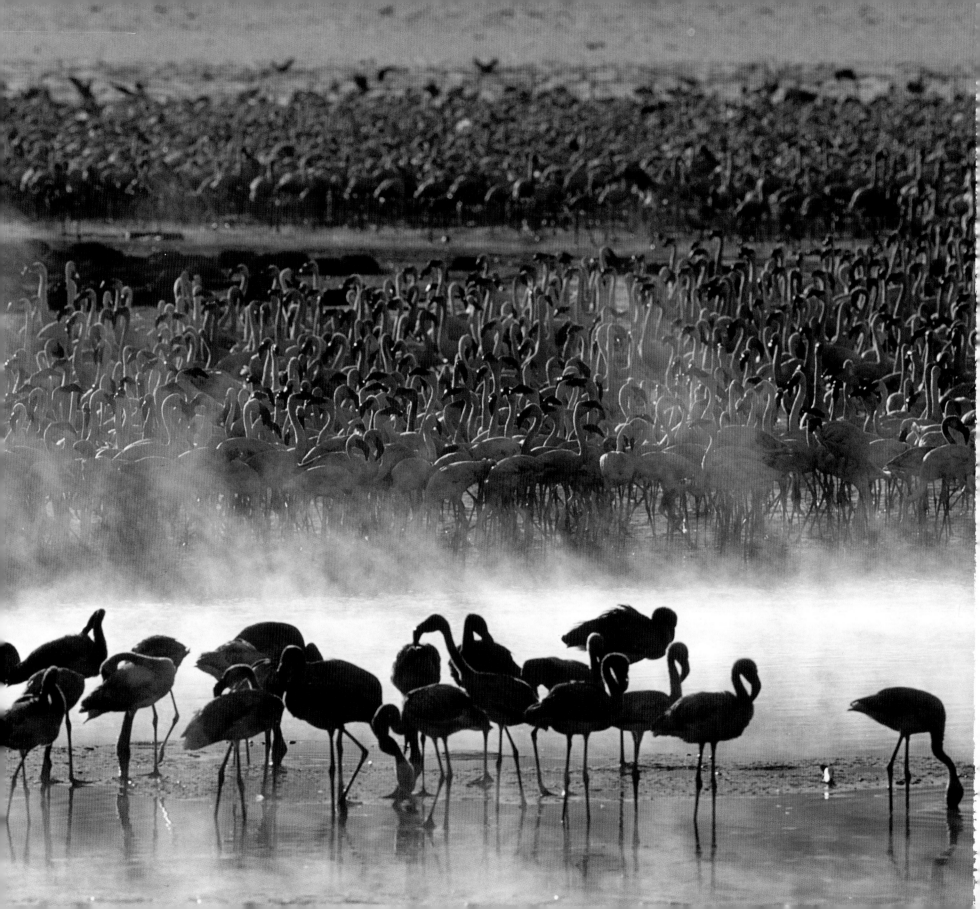

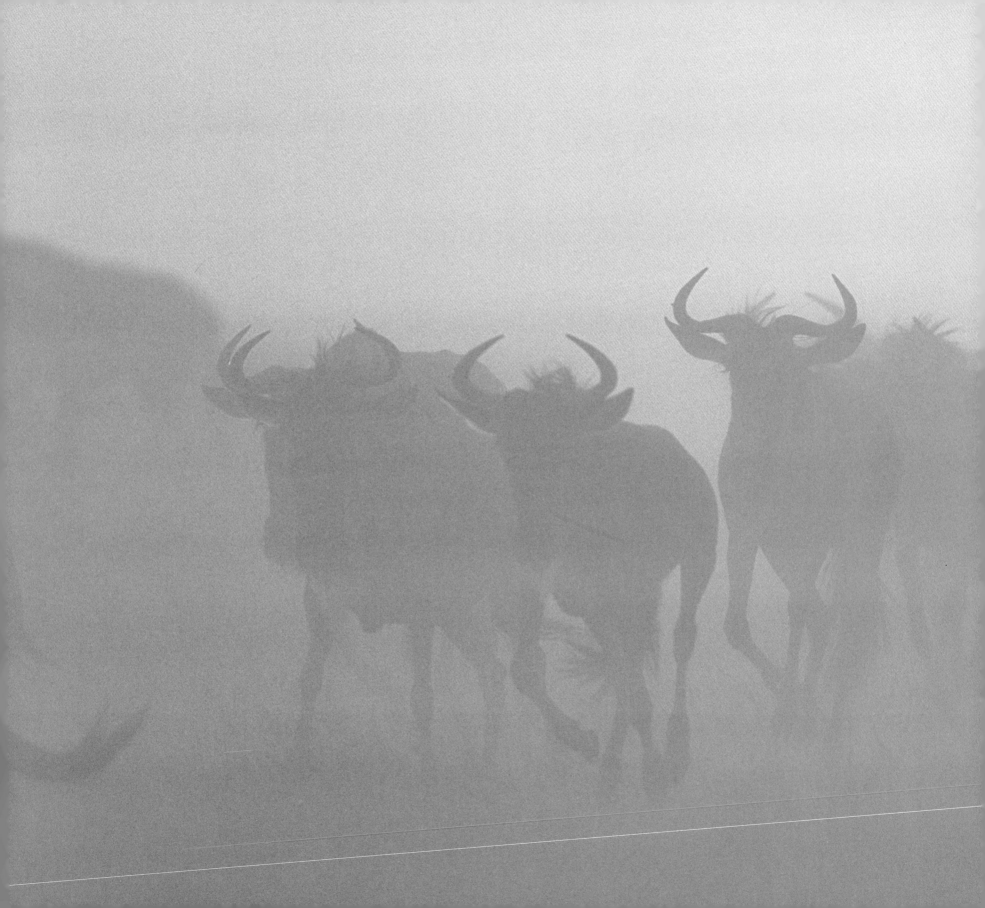